IMAGES
of America

DUBLIN

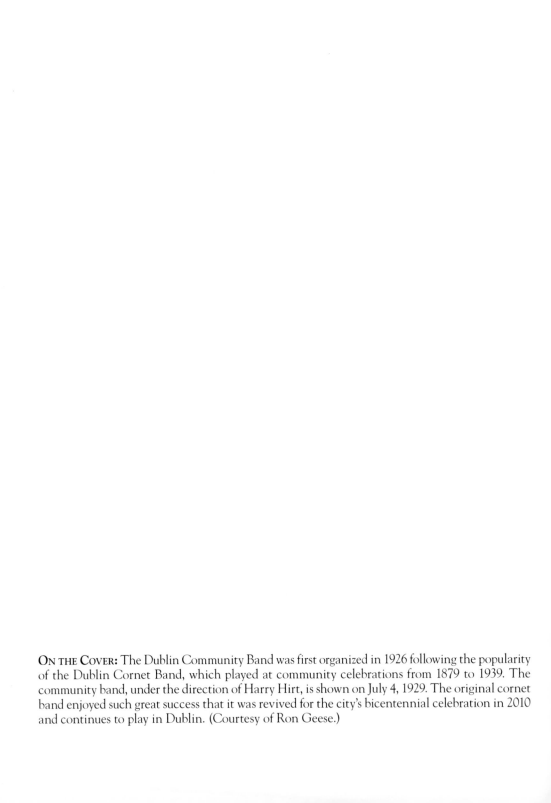

ON THE COVER: The Dublin Community Band was first organized in 1926 following the popularity of the Dublin Cornet Band, which played at community celebrations from 1879 to 1939. The community band, under the direction of Harry Hirt, is shown on July 4, 1929. The original cornet band enjoyed such great success that it was revived for the city's bicentennial celebration in 2010 and continues to play in Dublin. (Courtesy of Ron Geese.)

IMAGES
of America

DUBLIN

Nancy L. Richison

ARCADIA
PUBLISHING

Published by Arcadia Publishing
Charleston, South Carolina

Printed in the United States of America

Library of Congress Control Number: 2014940633

For all general information, please contact Arcadia Publishing:
Telephone 843-853-2070
Fax 843-853-0044
E-mail sales@arcadiapublishing.com
For customer service and orders:
Toll-Free 1-888-313-2665

Visit us on the Internet at www.arcadiapublishing.com

*For my children, Laurel and Henry Rozenman,
and in loving memory of my late husband, Martin Rozenman*

CONTENTS

Acknowledgments 6

Introduction 7

1. The Early Years 9

2. The Young Pioneers 21

3. Turn of the Century 35

4. Modern Times 47

5. Athletic Pursuits 69

6. Excellence in Education 73

7. A Sense of Place 85

8. Jack Nicklaus Discovers Dublin 93

9. Celebrating the City 103

10. Booming Business 111

ACKNOWLEDGMENTS

This book would not be possible without the help and support of a wide variety of people starting with my editor Maggie Bullwinkel, Mary Margaret Schley, and the staff at Arcadia Publishing. I am grateful for their help and guidance in keeping this project on track. I also wish to thank Tom and Gayle Holton of the Dublin Historical Society for going above and beyond to ensure that the historical society would be well represented. I also wish to thank those who contributed the photographs for this book, especially Ron and Anne Geese, Carolyn Geese Herron, and Laurie Termeer. Your dedication to preserving your family's history is much admired. I also would like to thank Nick Taggart of the Columbus Metropolitan Library; Joe Meyer of the *Dublin Villager*; Mary Jo DiSalvo of the City of Dublin; Ryan McDonnell, Rebecca Felkner, and Wendy Greenwood of the Grandview Heights Public Library; Shelley Bird and Stephanie Pavol of Cardinal Health; Amanda Murphy of OCLC; Kitty Munger of The Wendy's Company; Toby Brief of the Columbus Jewish Historical Society; and Janet Cooper of the Dublin Arts Council. Thanks go to Sue Timan, Elaine Ragan, Sandy Blanquera, and Lisa Mueller for their friendship, support, and encouragement of this project, and to my children, Laurel and Henry Rozenman, for always reminding me what truly matters in life. I also would like to acknowledge the following sources for helping to fill in the nuances behind Dublin's rich history: *Dublin's Journey*; Official Program of Dublin Area Sesquicentennial Celebration; handwritten records of Fay Eberly and Newton J. Dominy; Dublin Historical Society; Dublin Community Church newsletter; Columbus Metropolitan Library; family histories written by Virginia Lynn Geese, John Geese, Helen (Mitchell) Geese, and Dick Termeer; *The Ohio State Engineer* magazine; Dominy.com; Ohio Memory.com; *History of Early Dublin Churches*; *Dublin Villager*; Fundinguniverse.com; Muirfield Village sales brochure; the Memorial Tournament; *History of Franklin and Pickaway Counties, Ohio*; *Dublin Cemetery Guidebook*; *Shanachie*; Dublin Community Church; *From Leatherlips to Microchips* by Scott T. Weber; *The Shamrock*; Ancestry.com; and the Ohio Historical Society.

INTRODUCTION

The history of Dublin, Ohio, is told by its people—the ones who carry the same names as the original settlers, like the Sells, Karrers, Mitchells, Davises, Tullers, Shrivers, Coffmans, and many more. These are the same names that you will find on many of the roadways and school buildings in Dublin, and they are the same names that you will find on mailboxes of local homes and the rosters for city boards and commissions. These people built the community and have archived its history.

Among these pages, you will see the faces of their ancestors and you will understand the resolve that continues to shape the Dublin of today, from the time when Lt. James Holt first received the land located in the Virginia Military District for his service in the Continental Army during the Revolutionary War to 1810, when John Sells asked Irish surveyor John Shields to name the newly platted "Sells Town." Shields is said to have responded, "If I have the honor conferred upon me to name your village, with the brightness of the morn, and the beaming of the sun on the hills and dales surrounding this beautiful valley, it would give me great pleasure to name your new town after my birthplace, Dublin, Ireland."

The Irish theme has played out in the heritage of the community, but Dublin is truly a melting pot, shaped by settlers of different heritages. And each has impacted the community—from the first Native Americans to the nearly "Wild West" shenanigans of the settlers in the 1800s, to the pioneering determination of farmers and merchants who followed, and the wholesomeness of the families who chose to stay and raise their own children here.

The hardships suffered while building their shelter, serving in war, or struggling to make a living were overcome with an indomitable spirit to build a sense of community.

In more modern times, the town took off in the 1970s, experiencing rapid growth like never before with the construction of Interstate 270, the arrival of Ashland Chemical Co. (now Ashland Inc.), and the development of the Muirfield Village Golf Club and residential community by golfing legend Jack Nicklaus.

Throughout the years, one thing has remained constant: a feeling of celebration and the presence of parades and bands to add to the festive atmosphere—on St. Patrick's Day, Independence Day, and during the Dublin Irish Festival.

Dublin celebrated its sesquicentennial in 1960 and its bicentennial in 2010, but perhaps there was no time to be more proud to be a Dubliner than when the village became a city in 1987. That was when Dublin reached more than 5,000 in population. Today's Dublin numbers more than 40,000 residents.

And one of the things that attracts those residents is the quality of education. Dublin boasts excellent schools, with all three high schools routinely landing on *Newsweek*'s list of the best in the country.

Visionary leaders have assured that the infrastructure and innovation keep pace with the times. The New York–based Intelligent Community Forum has even called Dublin's high-tech environment an Intelligent Community. Its corporate headquarters, such as Cardinal Health, The Wendy's Company, and Stanley Steemer, are well-respected international companies, and Dublin continues to encourage the ideas of self-made men and women through its Dublin Entrepreneurial Center.

Today, Dublin has one of the nation's largest Irish festivals, and thanks to Nicklaus's golf course, Dublin is the only city in the world to have hosted a Ryder Cup, Solheim Cup, and Presidents Cup.

But this book is not about the Dublin of today; it is about the Dublin of yesterday and its then residents, their crafts and talents, spirit of adventure, and tenacity that molded the modern city that Dublin has become.

Little did those early settlers know that the green associated with the Irish name would be prevalent among Dublin's emerald fields with its 1,200 acres of parkland, more than 100 miles of bike trails, and recognition for exemplary landscaping codes.

They also did not know that the Wyandot chief who befriended the Sells family would be forever commemorated in the city's public art program followed by many more installations, including 109 human-size concrete ears of corn that pay homage to Dublin's agricultural roots. The Arts in Public Places program, a partnership between Dublin Arts Council and the city, has commemorated other historical aspects of the town, including a *Jack Nicklaus Tribute Sculpture*, *The Simulation of George M. Karrer's Workshop*, and *Daily Chores*, which acknowledges the town pump that was once located at the intersection of Bridge and High Streets.

We are grateful for the contributions of all Dublin's people and for those who choose to preserve these milestones. From those families who eight generations ago sat for family portraits, to those who took photographs of local landmarks, and the families that carefully took their own historical notes, preserved records, and passed them down to younger generations, this is Dublin's history in photographs.

We hope you will enjoy reading the stories and understanding the lives of these early settlers. How interesting to note the different incarnations that various buildings have undergone throughout the eras. Credit goes to the City of Dublin for saving significant buildings like the Alexander Davis cabin, which was dismantled and reassembled at Indian Run Falls Park, and the George M. Karrer bank barn, which remains on what was once Karrer's property in Historic Dublin next to the artwork recalling his blacksmith shop.

We recognize that there are many untapped sources out there with their own unique stories to tell. We encourage you to continue to keep the history alive and to share it with others. The Dublin Historical Society offers opportunities to preserve these pictorial records and is a wonderful resource where you can begin.

Through a grant from the City of Dublin in 2009 to celebrate the bicentennial, the Dublin Historical Society and Dublin branch of the Columbus Metropolitan Library are collaborating with the city to digitize and preserve Dublin's history. One of these efforts is the Dublin History Collection on OhioMemory.com, a project of the Ohio Historical Society and the State Library of Ohio to create an online scrapbook.

One

THE EARLY YEARS

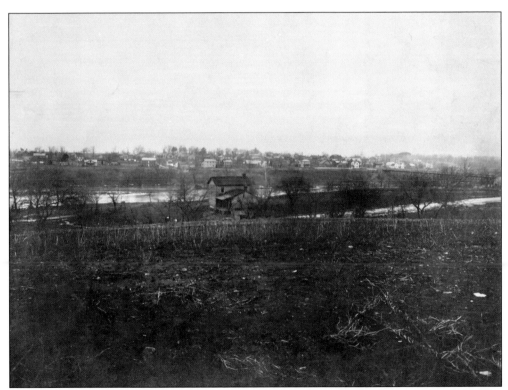

This is the settlement of Dublin, Ohio, as viewed from the east side of the river in 1812. The Washington Township School can be seen just across the bridge at right. At the time of this photograph, Dublin was being considered as a site for the state capital before an alternative plan was adopted, and the new capital was selected and named after Christopher Columbus. (Courtesy of Dublin Historical Society.)

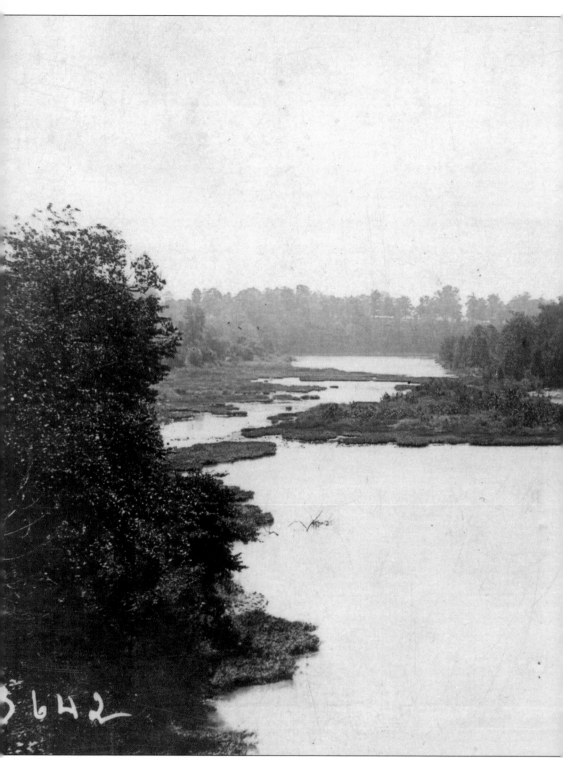

Looking south from Dublin along the Scioto River, Corbin's Mill can be seen in the distance. It was here at the mill where the river was forded before the construction of Dublin's first bridge.

The building at right is believed to be the barn belonging to the John Sells's property. (Courtesy of Columbus Metropolitan Library.)

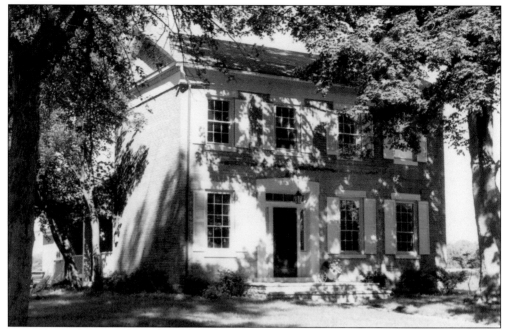

In 1801, Benjamin Sells came to Dublin from Huntingdon County, Pennsylvania, with his brother Peter to buy land for their father, Ludwick; their brothers, William, Samuel, and John; and themselves. Benjamin would marry Rebecca Ervin, and with their children, they lived in this home on what is now Hayden Run Road. (Courtesy of Dublin Historical Society.)

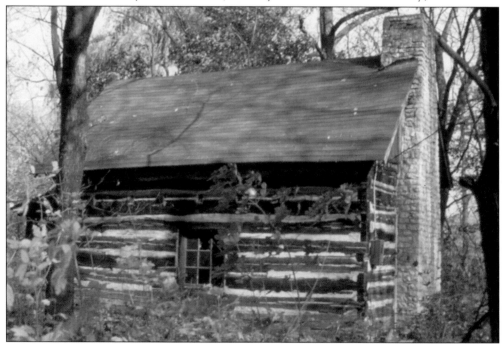

John Sells built this cabin around 1809 on the west bank of the Scioto River, just south of present-day Bridge Street. Today, John Sells Middle School, named in his honor, is a short walk away at 150 West Bridge Street. (Courtesy of Dublin Historical Society.)

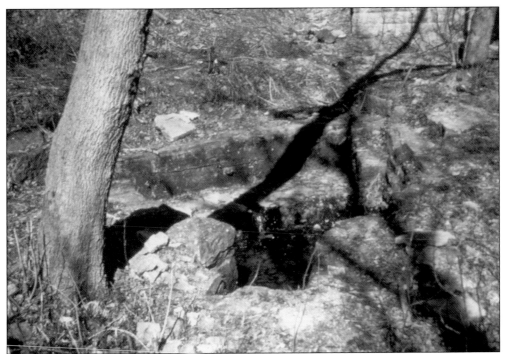

This spring, located on the west bank of the Scioto River at Riverview and Bridge Streets, was the main source of drinking water for early settlers and those passing through town. John Sells built his log cabin close to the spring, which remained the primary source for water until 1885, when a town pump was installed at Bridge and High Streets. (Courtesy of Dublin Historical Society.)

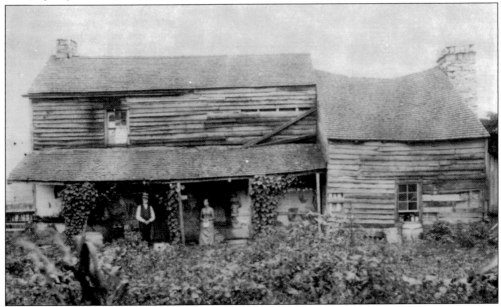

John Sells owned the first house built in Dublin in the early 1800s. The home was located on Water Street, which is now known as Riverview Street. The original house was actually a log cabin and served various purposes through the years; it served as a home, tavern, and church. (Courtesy of Dublin Historical Society.)

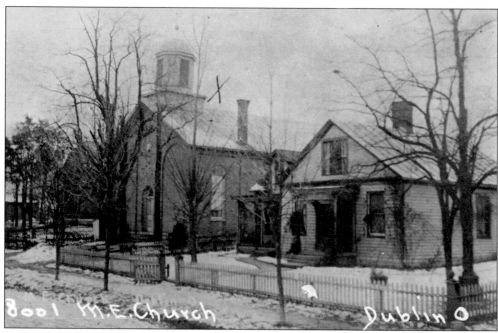

George Ebey began the Methodist Episcopal church in his home in 1808. It would become the first church to be built in Dublin when completed in 1837. Known as the Christie Methodist Episcopal Church, it was named in honor of Daniel Wright's father-in-law, the Rev. John Christie, who died in 1823. (Courtesy of Dublin Historical Society.)

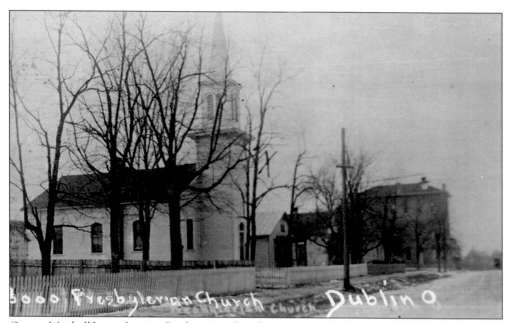

George Mitchell began hosting Presbyterian church meetings in his home in 1817. The Presbyterian congregation was organized in 1827, and Charles Mitchell began building the church in 1850. The building was completed in 1857. (Courtesy of Dublin Historical Society.)

The original St. John's Lutheran Church was built in 1856 on land on Avery and Rings Roads. F. Nuetzel, who served as its pastor and conducted services in German, had founded the church in 1855. A new church was built nearby to accommodate the growing congregation; along with its adjoining graveyard, it remains in the location today. (Courtesy of Dublin Historical Society.)

John Shields, a minister and the Irish surveyor who most credit with naming Dublin, began organizing Dublin's first Christian church in 1811. The church then built a log building at Bridge and High Streets on land belonging to Daniel Brunk. In 1912, a cyclone damaged the Methodist Episcopal and Presbyterian churches in Dublin. Their congregations merged with the Christian church, which remains the Dublin Community Church and is still active on Bridge Street. (Courtesy of Dublin Historical Society.)

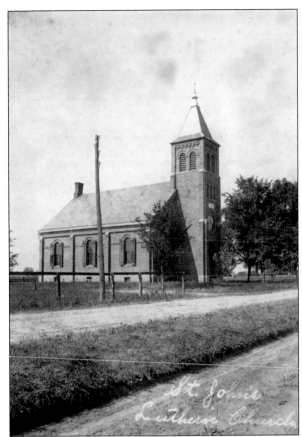

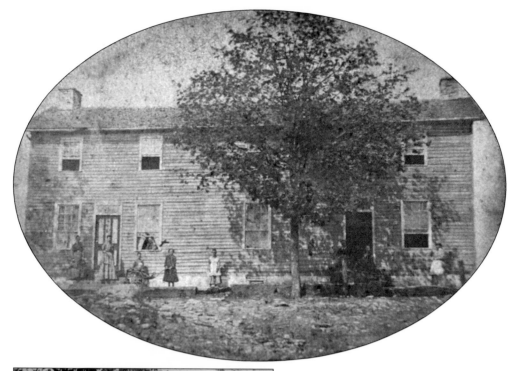

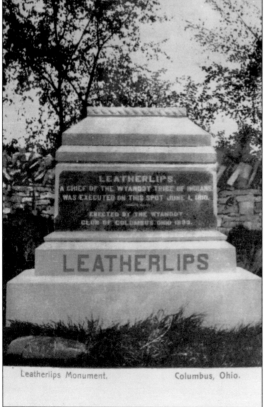

LEATHERLIPS,
A CHIEF OF THE WYANDOT TRIBE OF INDIANS
WAS EXECUTED ON THIS SPOT JUNE 1, 1810.

ERECTED BY THE WYANDOT
CLUB OF COLUMBUS OHIO 1889.

LEATHERLIPS

Leatherlips Monument. Columbus, Ohio.

The Black Horse Tavern, owned by John Sells, was located at 105–109 South High Street and was named for Sells's black stallion. Sells offered the horse to the Wyandot Indians in a failed attempt to save the life of Chief Leatherlips in 1810. It was here at the tavern that Sells met John Shields, the Irish surveyor believed to have named Dublin for his homeland. (Courtesy of Dublin Historical Society.)

Native Americans populated Dublin long before the first settlers arrived. These tribes included Adena, Hopewell, Shawnee, and Wyandot, whose chief, Shateyoranyah, was better known to the Sells family as Leatherlips. Wyandot warriors turned on their chief, executing him on charges of witchcraft, though those loyal to the chief believed it was because he opposed the war councils of Tecumseh. The site where he was executed in June 1810 is marked with a monument on Riverside Drive. (Courtesy of Columbus Metropolitan Library.)

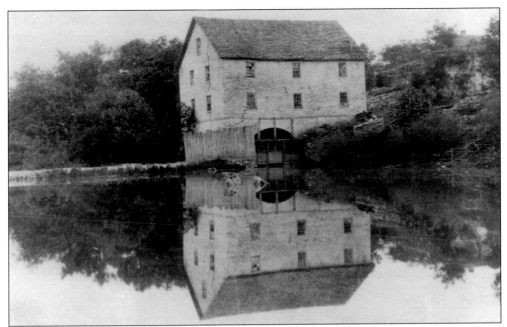

The first flour mill was built in 1812 by George Ebey and John Sells. The wood-framed mill was later owner by Joseph Corbin, who operated it until it was torn down in 1898. Joseph Corbin built Corbin's Mill, the stone mill on the west side of the Scioto River, in 1855. (Courtesy of Dublin Historical Society.)

Benjamin Sells's house was built on Hayden Run Road, which was just south of the Dublin settlement. This bridge was used to cross the Scioto River. Hayden Run took its name from local blacksmith Joab Hayden, who was described as an eccentric genius and owned a farm on the road where he collected wild bees to produce honey. (Courtesy of Dublin Historical Society.)

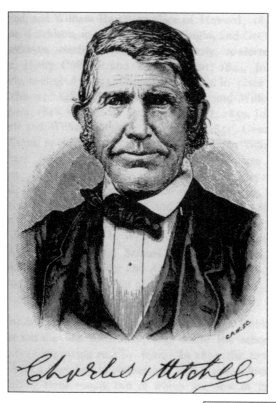

Charles Mitchell Sr. arrived in Dublin in 1815 from Robstown, Pennsylvania, with his wife, Jane (Robinson) Mitchell, and 10 children. They took up residence in Washington Township, a half mile north of Dublin. His son, Charles Mitchell Jr. (pictured), married Eliza Reed on September 1, 1835. (Courtesy of Columbus Metropolitan Library.)

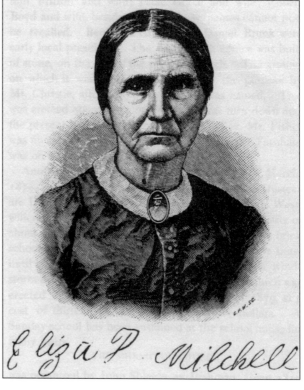

Eliza (Reed) Mitchell was the daughter of Samuel Reed of Union County. She and her husband, Charles Mitchell Jr., had four daughters and three sons: Martha, Calvin, Anne, Olive, Mary, Charles, and Luther. (Courtesy of Columbus Metropolitan Library.)

Mary E. Mitchell, pictured at right, was born
December 12, 1848. She married Frank P. Goble,
son of Peter Goble and Ann Eliza Chapman, on
November 16, 1871, in Dublin. Frank Goble worked
as a funeral director. Below, Mary is shown with her
niece Mary Mitchell, the daughter of Luther and
Julia (Armstead) Mitchell, who died at the age of 27.
(Right, courtesy of Carolyn Geese Herron; below,
courtesy of Carolyn Geese Herron and Ron Geese.)

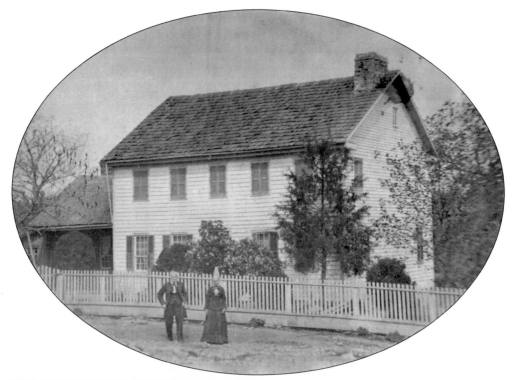

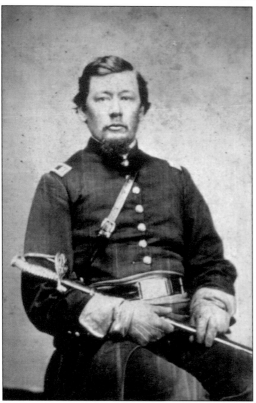

The Mitchell family home, built in 1812, began as a log cabin on the property where the family first lived along the Scioto River near where Interstate 270 and Emerald Parkway cross the river today. Shown in front of the house are Charles Mitchell Sr. and his wife, Jane (Robinson) Mitchell. (Courtesy of Carolyn Geese Herron.)

The son of Benjamin and Elizabeth (Davis) Sells, Orange Sells was born February 8, 1836. At the age of 27, he enlisted in and became captain of the 12th Ohio Cavalry. He was wounded in the Battle of Saltville (Virginia) in 1864, and later served as the first mayor of Hilliard and superintendent of the Ohio Statehouse. He died June 12, 1915, and is buried in Green Lawn Cemetery in Columbus, which is also the final resting place of his father. (Courtesy of Dublin Historical Society.)

Two

THE YOUNG PIONEERS

Dr. Albert Chapman became Dublin's first physician in 1830. Dr. Chapman, who married Lucy Sells, was known for riding around the countryside making house calls on horseback. He would later lose his license when the State of Ohio declared him incompetent to practice medicine. Dr. Chapman's other careers included storekeeper, land speculator, and lender. Albert Chapman Elementary School is named in his honor. (Courtesy of Dublin Historical Society.)

Attorney James E. Wright married Lizzie Davis, daughter of one of Dublin's first settlers, Samuel Davis, and his wife, Elizabeth, in 1850. The son of another of Dublin's founders, Daniel Wright, James graduated from Princeton and served as the Franklin County treasurer from 1869 to 1877. Ele W. Tuller studied law in Dublin under Wright's tutelage. (Courtesy of Columbus Metropolitan Library.)

Holcomb Tuller of Simsbury, Connecticut, married Jane Woodruff and moved to Dublin in 1836. The family included, from left to right, Elvira, Jane, Ele, Woodruff, Holcomb, and John Tiberius Tuller, as shown in the 1850s. Holcomb Tuller operated a few businesses in what is now Historic Dublin, including a general store and an ashery, in addition to a flour mill on the Scioto River. Following the death of his wife in 1855, he married Mary Sells. (Courtesy of Dublin Historical Society.)

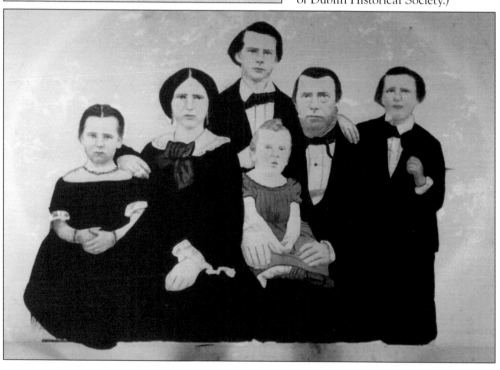

Ele W. Tuller, one of Holcomb and Jane (Woodruff) Tuller's eight children, graduated from Granger's Commercial College in Columbus in 1859. He was elected treasurer of Dublin in 1881 and to one term in the Ohio General Assembly in 1899. He married Sarah E. Everitt in 1862 and pursued a variety of businesses, including farming, real estate, and general mercantile. (Courtesy of Columbus Metropolitan Library.)

Jefferson Fulton worked for Ele W. Tuller at his farm on Sawmill Road where the Tullers raised thoroughbreds and Belgian show horses. Fulton and his wife, Minnie Hord Fulton (pictured on their 50th anniversary), lived in a five-bedroom home on the farm with their seven children. One hundred years later, the Tuller Fruit Farm would become known for its doughnut shop, which drew crowds from miles around in the 1960s, 1970s, and 1980s. (Courtesy of Dublin Historical Society.)

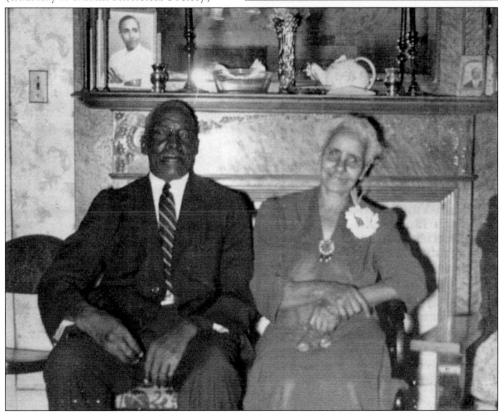

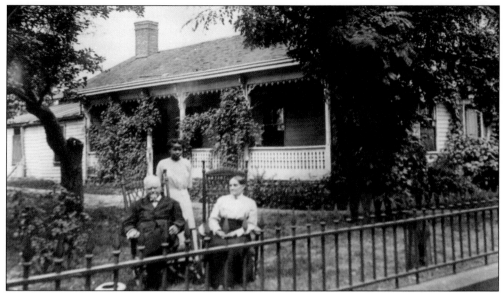

Ele W. Tuller and his wife, Sarah, are pictured at their home on South High Street, which was known at the White Cottage, around 1890. One of the daughters of Jefferson and Minnie (Hord) Fulton is standing behind them. (Courtesy of Dublin Historical Society.)

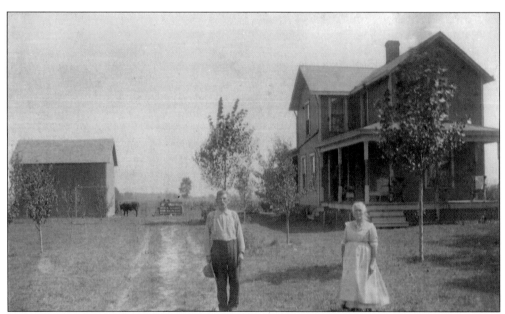

Martin Luther Mathias, a carpenter and builder, is shown with his wife, Amanda Dominy Mathias. Martin was born on April 3, 1841. He served in the Civil War from 1861 to 1864 before marrying Amanda and settling into their log farm home three miles north of Hilliards, which is known today as Hilliard. They eventually moved to a country home one mile south of Grove City on Harrisburg Pike. (Courtesy of Carolyn Geese Herron.)

Built between 1862 and 1867, the Fletcher Coffman Homestead was a 119-acre farm belonging to the oldest child of Henry and Margaret (Sells) Coffman. Fletcher and his wife Marinda (Hays) lived in the home; there was also a 19th-century barn on the property. Restored in the 1980s, the property is now home to the Dublin Historical Society, which offers tours on the first Sunday of the month from May through September. (Courtesy of Dublin Historical Society.)

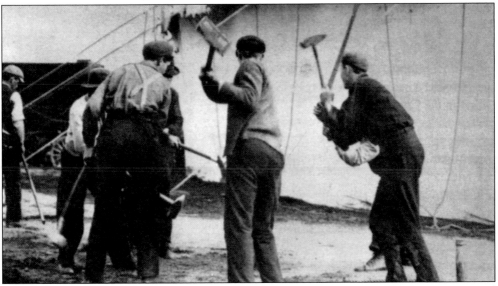

The Sells brothers, Ephraim, Lewis, Peter, and William Allen, brought the circus to Central Ohio in 1871. Here, workers pound stakes into the ground as they set up one of the tents. The Sells brothers were the grandsons of Ludwick Sells, one of the first settlers of the area. Before long, the circus hit the road traveling the country in horse-drawn wagons, and later by train. The Sells Brothers Circus would eventually become part of Ringling Bros. (Courtesy of Dublin Historical Society.)

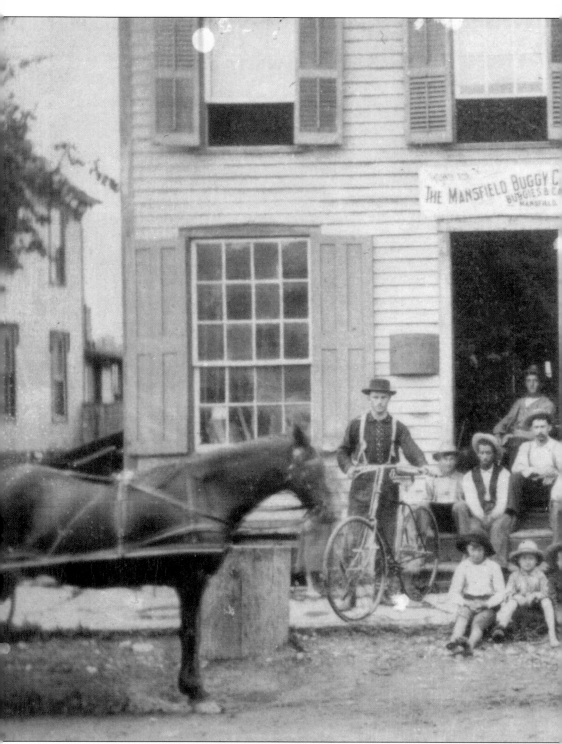

Dublin's first post office was in a building shared with the Mansfield Buggy Co. In 1820, Daniel Wright became Dublin's first postmaster, serving until 1825. The new post office meant Dubliners no longer had to travel the 12 miles to Franklinton to pick up their mail. By the end of his term,

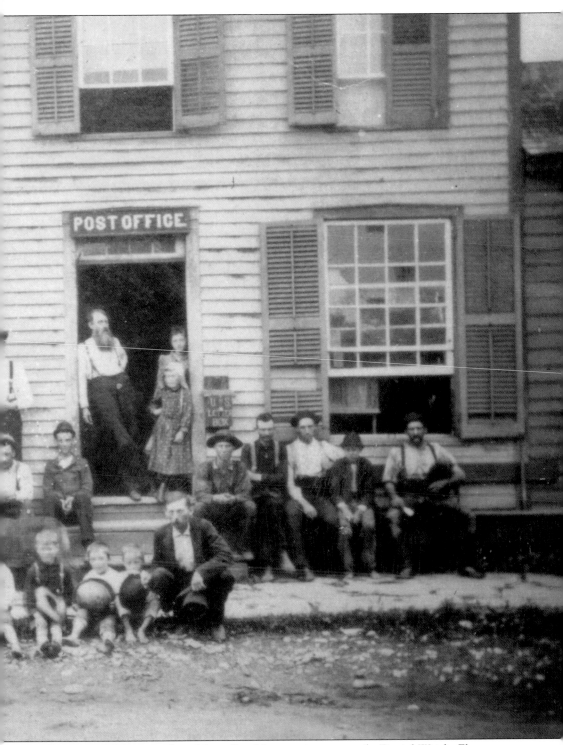

Wright received deliveries of mail from Franklinton via stagecoach. Daniel Wright Elementary School is named in his honor. (Courtesy of Laurie Termeer.)

Slater B. Shriver was born on December 22, 1857, in Pennsylvania. He came to Dublin with his parents. After marrying Hattie Mathias in 1867, the couple built a house on Slater's parents' farm where they raised their daughter, Carrie, who was born in 1888. Carrie married Frank R. Mitchell, a descendant of Charles W. Mitchell Sr. (Courtesy of Carolyn Geese Herron.)

Minnie Mabel Ashbaugh is pictured as a young girl in this portrait. The daughter of David Roney Ashbaugh and Almeda Harriette McKitrick, she married Ralph Morris Dix. Minnie's father had a daughter and two sons with his first wife, Arvilla, who died in 1880, and three daughters with his second wife, Almeda. (Courtesy of Carolyn Geese Herron.)

Before being elected as a Franklin County commissioner, Daniel Matheney was a Dublin blacksmith for three years, though his primary source of business was as a stockbroker. He served on the commission from 1875 to 1881. He married twice, first to Martha Hutcheson and then following Martha's death to Susan Ruth Hutchinson, the daughter of Amaziah Hutchinson Jr. and Mary (Ebey) Hutchinson. (Courtesy of Columbus Metropolitan Library.)

Milton T. Smiley was the first clerk of Dublin in 1881 and later became mayor, serving from 1884 to 1886. He married Mary A. Putnam on January 23, 1869, and they had a daughter, Nannie Smiley Davis, who is shown in the inset of this 1901 photograph. Milton Smiley's grandfather David founded Smiley's Corners, which was six miles north of Columbus. (Courtesy of Columbus Metropolitan Library.)

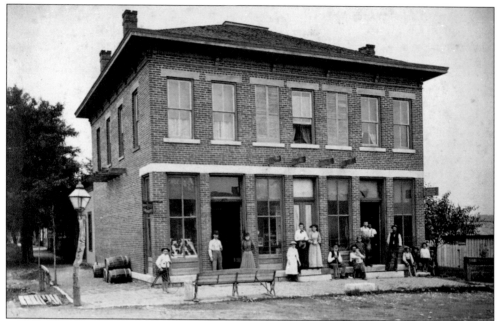

Wing's Grocery and Harness Shop once stood at the northeast corner of Bridge and High Streets where Domino's Pizza is today. The building was demolished in 1935 to accomodate the new bridge over the Scioto River. Members of the Wing family pictured are George Wing (on bicycle); Charles Melville "Mel" Wing and his wife Dora Davis Nicholson (second and third from left); Linnie Wing (young girl in white dress), Iva Wing, and their mother, Amanda Wing; and owner Fredrick Wing (to the right of last doorway). (Courtesy of Dublin Historical Society.)

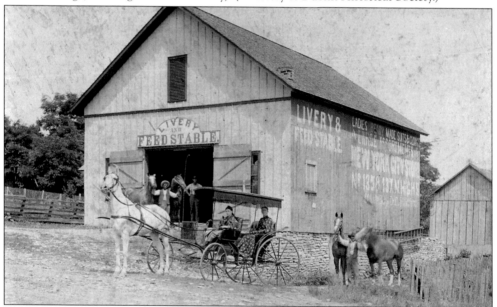

Wing's Livery & Feed Stable was located on Bridge Street between North High Street and the Scioto River. Owner Fredrick F. Wing is shown in the right of the door, while his daughter Linnie (Wing) Chapman and Amanda Wittich Wing sit in the carriage. Hiram "Pappy" Judson is holding the horses to the right of the stable. (Courtesy of Dublin Historical Society.)

Anna May "Annie" Mitchell was born about 1875 to Charles and Susan Melvina (McCauley) Mitchell. Annie, who is shown at left in a portrait taken in Dublin in 1885, had two sisters. Her brother died as an infant. At the age of 21, she married Newton J. Dominy in Worthington. Annie died in 1953. (Both courtesy of Laurie Termeer.)

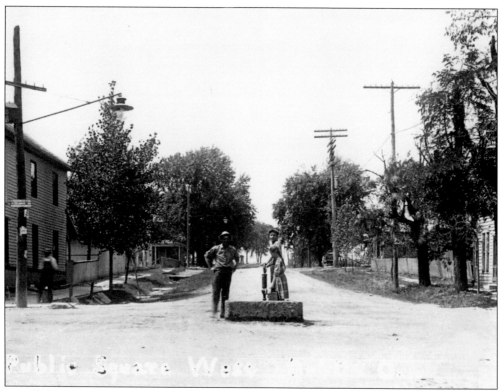

Installed in the 1890s at the intersection of Bridge and High Streets, the town pump served as a primary water source for early Dublin residents, travelers, and the era's main source of transportation—horses. The pump remained at the intersection until 1925, when it was removed after it became a safety hazard when an automobile crashed into the barrier surrounding it. (Both courtesy of Dublin Historical Society.)

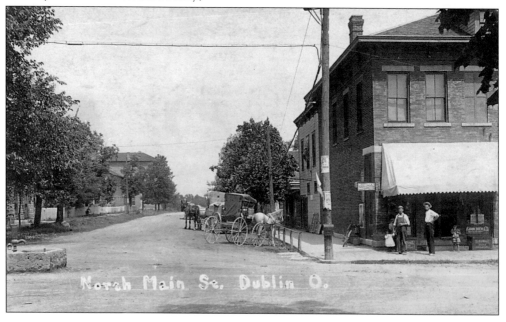

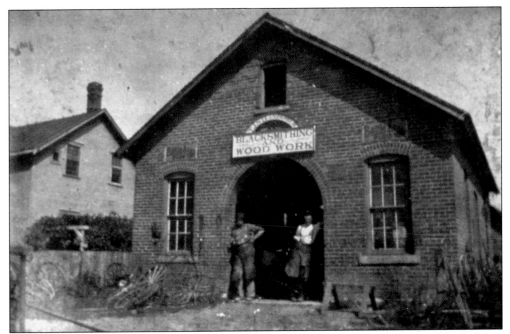

Located at 32 West Bridge Street, the Steinbower blacksmith shop was built in 1877. The building would later serve as a gas station in the 1930s, and today it is home to a veterinary clinic. It was owned by T.J. Steinbower, the German immigrant who would go on to become mayor of Dublin. (Courtesy of Dublin Historical Society.)

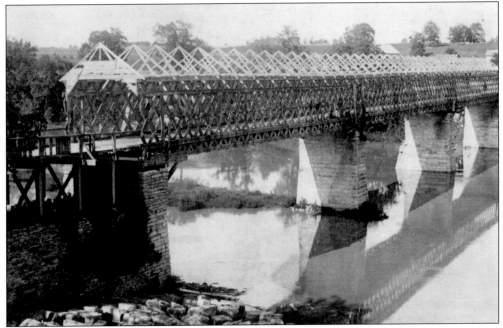

The first of several versions of the Bridge Street Bridge across the Scioto River was a covered wooden bridge erected around 1840. To make way for a new steel bridge in 1885, the wooden bridge had to be dismantled. The steel bridge was in use until 1935, when a stone bridge was built as part of the Works Progress Administration program. (Courtesy of Dublin Historical Society.)

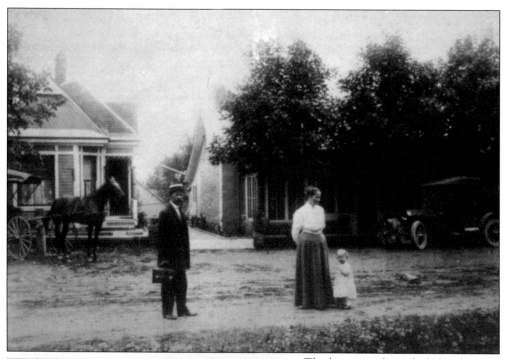

The home on the right behind Dr. Lewellyn McKitrick is located at 16 North High Street and was once owned by Zenas Hutchinson and would later become the home and medical office of Dr. Harry Osborn Whitaker and his wife, Nellie. In 2014, it is home to Our CupCakery. (Courtesy of Dublin Historical Society.)

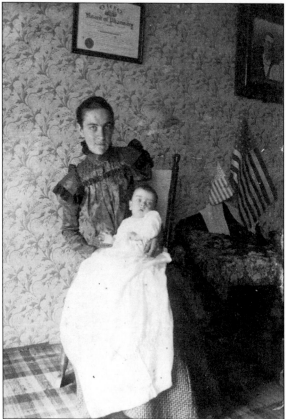

Anna (Mitchell) Dominy holds her son Norman Llewellyn Dominy, who died at the age of 16 months. She sits below her husband Newton Dominy's Ohio Board of Pharmacy certification. Newton graduated as a pharmacist from the Ohio Medical College in 1896 and spent 10 years as a pharmacist in Dublin. (Courtesy of Laurie Termeer.)

Three

TURN OF THE CENTURY

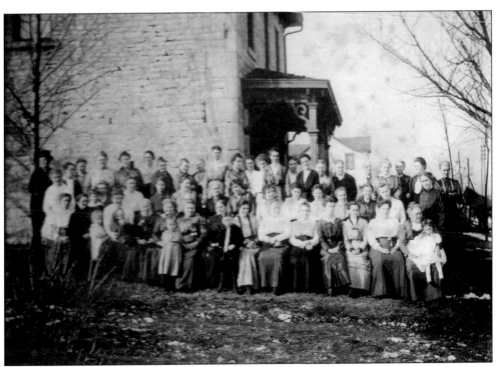

Ladies of Dublin gather on the south side of 75 South High Street for a photograph. The building, which is now Ha'penny Bridge Imports of Ireland, was the home of Charly Thomas at the time, according to the inscription on the back of the photograph. Charles Thomas was the son of John M. Thomas and Almira N. Hutchinson, who was the daughter of Amaziah Hutchinson Jr. and the granddaughter of George Ebey. (Courtesy of Carolyn Geese Herron.)

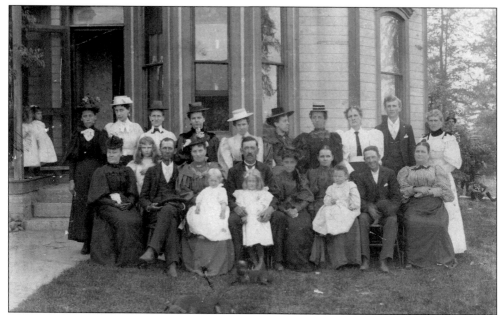

This c. 1915 photograph shows a gathering of the descendants of Charles Mitchell Sr., who was born March 9, 1746, in Robstown, Pennsylvania. He had two daughters and a son with his first wife. He married Jane Robinson in 1791 and had six sons and one daughter with her. The family moved to Dublin in 1815. Mitchell bought 1,070 acres of land that adjoined the Sells brothers' property from Walter Dunn. (Courtesy of Carolyn Geese Herron.)

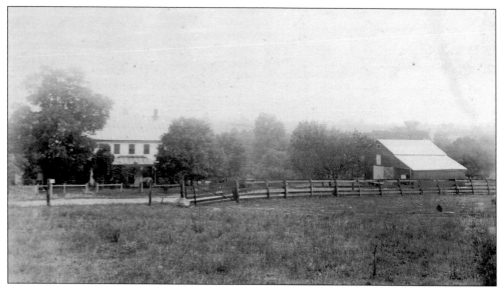

The Charles Mitchell Sr. family lived on this Dublin Road farm, which remains in the same location today, 6992 Dublin Road. The original log cabin is located on the north side of the home. Emerald Parkway today has since replaced the trees in the center of the photograph. The home is listed in the National Register of Historic Places. (Courtesy of Ron Geese.)

Harlan Mitchell and his dog are seen in this photograph from the early 1900s. Harlan, the son of Luther and Julia C. Mitchell, was born in 1897 and died in 1940 at the age of 43. He and his wife, Forest M. Shaffer, of Cardington, married on June 17, 1914, and resided on his farm in Dublin. (Courtesy of Carolyn Geese Herron.)

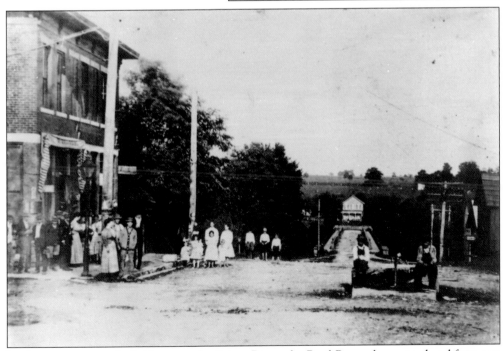

Looking east across the bridge over the Scioto River, the Basil Brown homestead and farm can be seen behind the town pump. Folks are gathered on the northeast corner of Bridge and High Streets in front of Wing's Harness and Grocery Shop. (Courtesy of Dublin Historical Society.)

Dublin's first bridge across the Scioto River was a covered bridge built in the early 1800s. This steel bridge replaced it in 1885 and served the community until 1935, when a stone bridge was constructed as part of the Works Progress Administration program. That bridge remained until October 15, 1986, when the city dedicated a modern four-lane stone bridge. The photograph below shows the view looking east across the steel bridge toward the Basil Brown farm at center. (Both courtesy of Dublin Historical Society.)

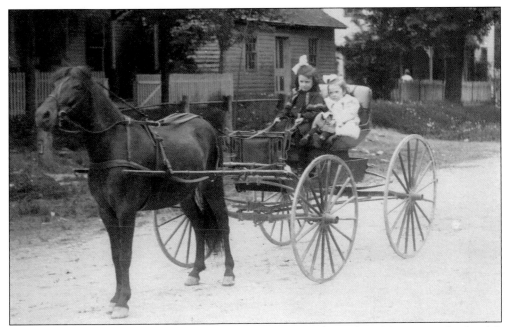

Eleanor and Ruthella Dominy are in a horse and buggy in the early 1900s next to the family's home at 29 South High Street. Eleanor was born March 6, 1903, and her younger sister Ruthella arrived November 27, 1905. (Courtesy of Laurie Termeer.)

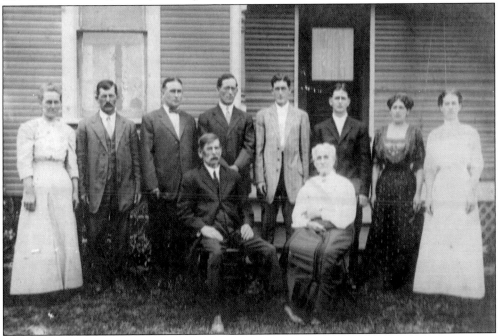

Martin Luther Mathias and Amanda Dominy Mathias celebrated their 50th anniversary in 1916 with their children, who are standing behind them, from left to right, Hattie Mathias Shriver, Albert Mathias, Henry Mathias, Harvey Mathias, Chancey Mathias, Ray Mathias, Fay Mathias Cremeans, and Flora Mathias Cremeans. Henry and Harvey and Ray and Faye were twins. Martin and Amanda married June 21, 1866. (Courtesy of Carolyn Geese Herron.)

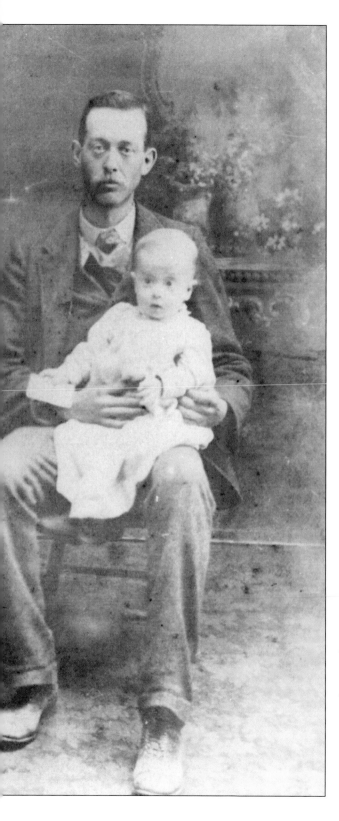

Four generations of the Dominy family are depicted in this portrait from 1903. From left to right are Jeremiah Dominy, a farmer by trade, who died on June 18, 1921; Henry Dominy, also a farmer, who died on February 8, 1905; and Newton J. Dominy, a pharmacist, contractor, and postmaster of Dublin, who died on January 2, 1959. Newton is holding his son Corliss Newton, who was born on May 3, 1901, and died on August 18, 1904. (Courtesy of Laurie Termeer.)

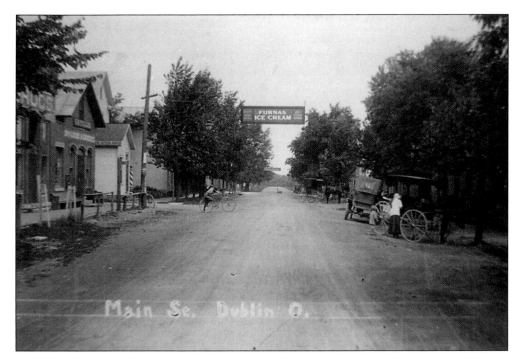

Here are two views of Dublin's "Main Street," what is known as High Street. In the 1920s photograph above, looking north, a barber pole is visible. The iconic symbol can be found on South High Street today. The photograph below shows Coffman Corner on the right. (Both courtesy of Dublin Historical Society.)

Pictured in 1915, baby Helen and Aleta Mitchell were the daughters of Frank and Carrie (Shriver) Mitchell. Carrie was the daughter of Slater and Hattie Mathias Shriver. Carrie was born in 1888 and died in 1978. Frank died in 1959 and is buried in the Dublin Cemetery. (Courtesy of Ron Geese.)

Susan Melvina "Vina" (McCauley) and David Bates are pictured in front of the Mitchell House Hotel in 1919. Vina married David Bates after her first husband, Charles W. Mitchell III, died at the age of 51. People came from all around to eat dinner at the Mitchell House, which also served as a boardinghouse. Today, the structure is home to the Dublin Barbershop. (Courtesy of Laurie Termeer.)

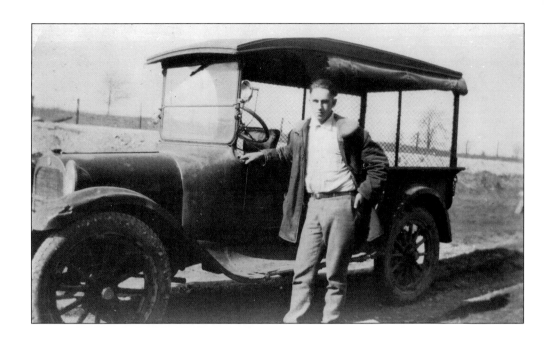

Harlan Joseph Mitchell (1894–1940), a member of the fourth generation of the Charles Mitchell Sr. family in Dublin, quickly adapted to the new automobiles on the road. Harlan was the son of Luther and Julia C. Mitchell. He attended high school in Cardington, Ohio, where he met and married Forest M. Shaffer. (Both courtesy of Ron Geese.)

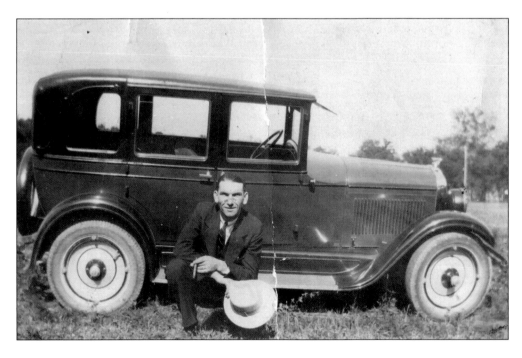

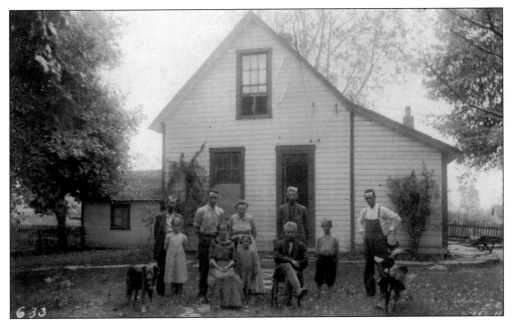

This photograph, taken on October 5, 1915, shows Luther Charles Mitchell and his wife, Elsie Shriver Mitchell, seated with members of their family surrounding them, including Willie Shriver and Mary Mitchell (Leonard). Luther was the son of Luther and Julia (Armstead) Mitchell. (Courtesy of Carolyn Geese Herron.)

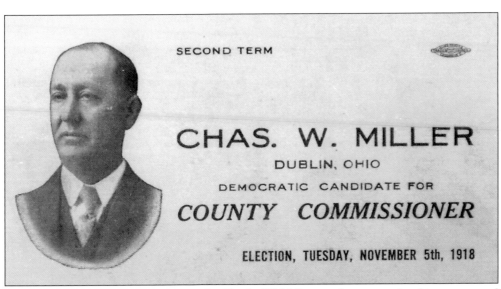

This business card campaign literature for Charles W. Miller urged voters to elect him to a second term for county commissioner in 1918. Miller, a Democrat, was successful in his bid for reelection. (Courtesy of Columbus Metropolitan Library.)

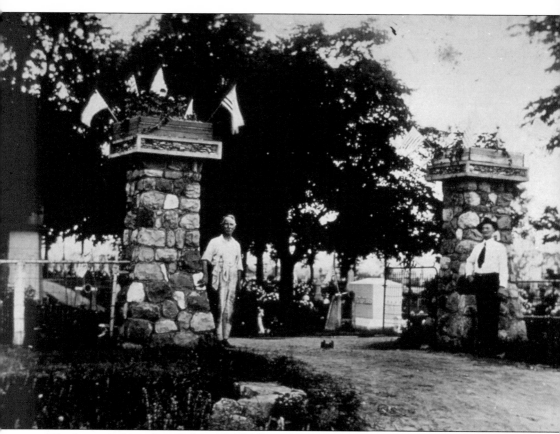

The former Independent Order of Odd Fellows Cemetery is today known as the Dublin Cemetery. Many of Dublin's earliest settlers are buried here, including Ludwick and John Sells, Eli Pinney, and Zenas Hutchinson. It was established in 1858, and the remains of several deceased were moved to the location from other burial sites. In this photograph, John Wing and John Snouffer stand outside the entrance to the cemetery on Bridge Street. (Courtesy of Dublin Historical Society.)

Four

MODERN TIMES

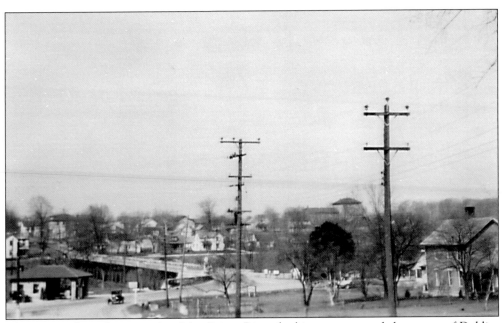

This view is from the east side of the Scioto River, looking west toward the center of Dublin. The three-story Washington Township School can be seen toward the center of the photograph (between the telephone poles). The Basil Brown farm is at bottom right, and the Brown-Thomas service station is at bottom left. The road across the bridge curved in front of the Brown farm to continue along what is now state Route 161. (Courtesy of Dublin Historical Society.)

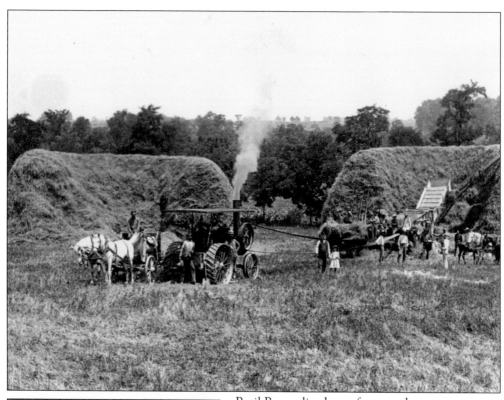

Basil Brown lived on a farm on the east side of the Scioto River at what is now state Route 161. Here, a few farmhands take a break while threshing—separating the wheat from the chaff—on the farm in the 1920s. (Courtesy of Dublin Historical Society.)

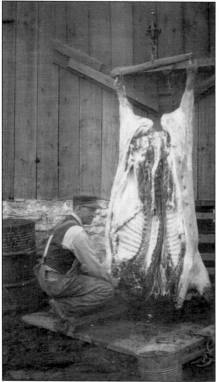

Carl Herman Karrer butchers a steer at his family's farm in Dublin in 1923. Carl was the son of George Michael and Mary (Farhbach) Karrer and was born in 1880. He married Ida Ritzhaup and died in 1960. Karrer is buried in Dublin Cemetery. (Courtesy of Dublin Historical Society.)

Stonemason Forest Woodland "Ticky" Wing (1873–1949) gained local notoriety for one of his sturdiest structures: an outhouse. Wing constructed the building in 1934 at his home on North High Street. Ticky's uncle, Fredrick Wing, owned Wing's Livery & Feed Stable and Wing's Grocery and Harness Shop. (Both courtesy of Dublin Historical Society.)

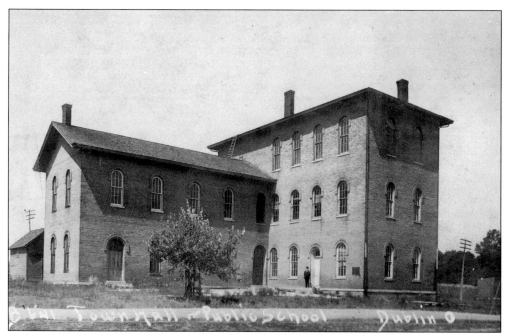

Built in 1871, the Washington Township School is seen here in 1908. The three-story building was located where the Dublin branch of the Columbus Metropolitan Library is today on North High Street. It served dual purposes, operating as both a public school and the town hall. It was torn down in the late 1970s. (Courtesy of Ron Geese.)

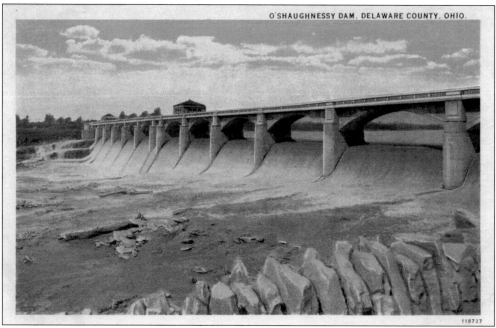

Located on the Scioto River, the O'Shaughnessy Dam was built in 1925 to store drinking water for the City of Columbus. The cost to build the concrete masonry dam and reservoir was $2.22 million. Named for Columbus Waterworks superintendent Jerry O'Shaughnessy, it was listed in the National Register of Historic Places in 1990. (Courtesy of Columbus Metropolitan Library.)

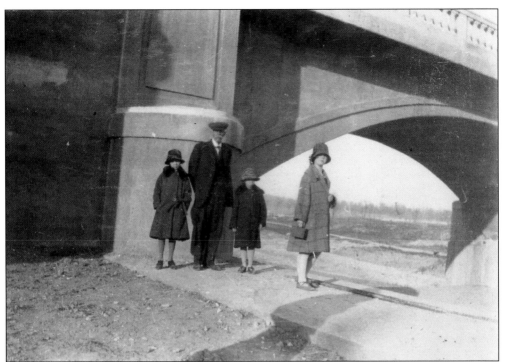

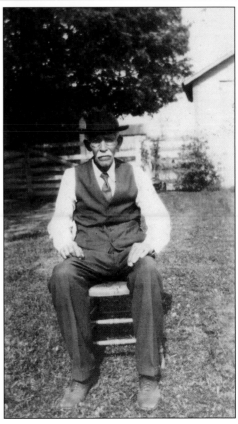

Aleta and Helen Mitchell visit the O'Shaughnessy Bridge with their grandfather Slater Shriver and an unidentified girl in the 1920s. Aleta is to the left of her grandfather, and Helen is to the right. The visit took place before the dam was built next to the bridge. At right, Slater poses for a photograph on the family farm. (Both courtesy of Ron Geese.)

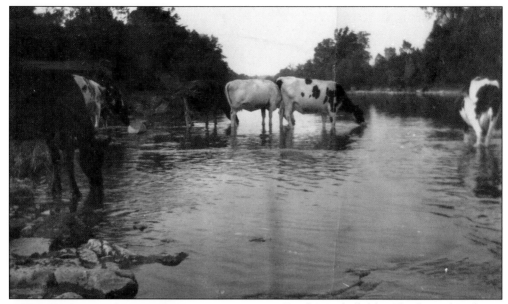

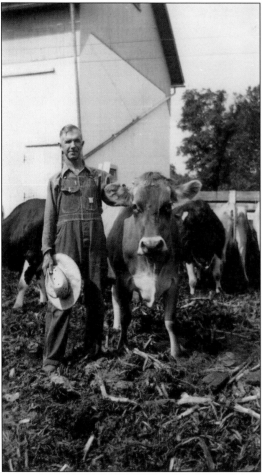

Frank Mitchell, like Charles and Luther Mitchell before him, took his cattle to the Scioto River behind the old Mitchell house to cool them off. In the photograph at left, he tends to the family farm he inherited from his great-aunt and great-uncle Mary and Frank Goble. (Both courtesy of Ron Geese.)

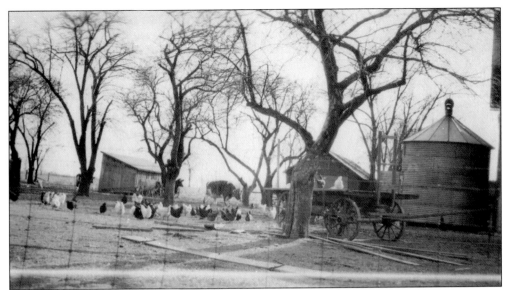

The 170-acre Goble family farm, which Mary (Mitchell) and her husband, Frank Goble, gave to Mary's great-nephew Frank Mitchell, who married Carrie Shriver, is shown here. The locust trees remain today. (Courtesy of Ron Geese.)

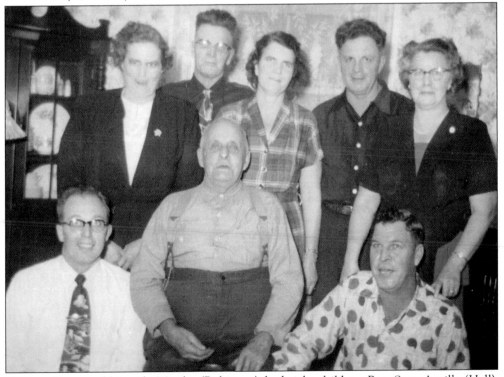

William Geese and his wife, Martha (Robinson), had eight children, Ray, Sam, Arvilla (Hall), Georgie (Leppert), Helen (Coffman), Ralph, Urton, and John. Shown here from left to right are (first row) John Geese, William "Poppy" Geese, and Ralph Geese; (second row) Arvilla (Geese) Hall, Sam Geese, Georgie (Geese) Leppert, Ray Geese, and Helen (Geese) Coffman. (Courtesy of Ron Geese.)

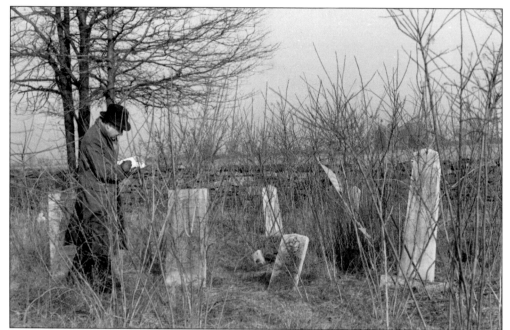

In 1939, a Works Progress Administration project hired field crews to inventory the Davis Cemetery, located on US Route 33 in Dublin. The cemetery contains graves of veterans of the Revolutionary War and the War of 1812. Ann Simpson Davis, who was a messenger for Gen. George Washington, is buried here. (Courtesy of *Columbus Citizen*, Scripps-Howard Newspapers/ Grandview Heights Public Library/Photohio.org.)

As a young girl, Ruthella (Dominy) Termeer rode the train to Indian Lake for vacations. Russells Point, the closest city on the lake, also featured an amusement park, Sandy Beach, which was built in the 1920s and was a popular destination for Central Ohioans. (Courtesy of Laurie Termeer.)

John and Helen (Mitchell) Geese are shown on their wedding day on May 25, 1938. The parents of Carolyn (Geese) Herron and Ronald Geese, the couple moved to the Geese family homestead on Sawmill Road before building a new house on Frantz Road. In later years, they lived at Coffman and Brand Roads before moving to Muirfield Village. (Courtesy of Ron Geese.)

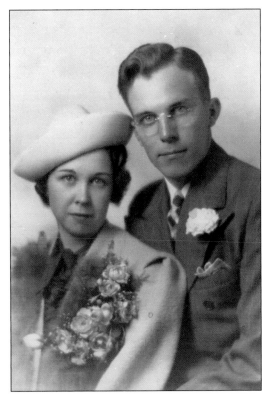

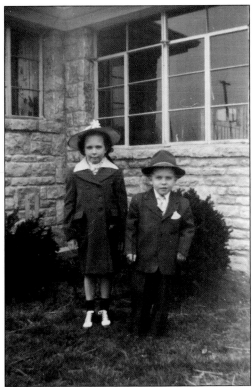

John and Helen (Mitchell) Geese's two children, Carolyn and Ron Geese, ages six and three, are seen in front of their house in 1948. Carolyn married Donn Herron, the son of grocer John Herron, and had two daughters. Ron and his wife, Anne Farmer Geese, have six children and live on Brand Road. (Courtesy of Ron Geese.)

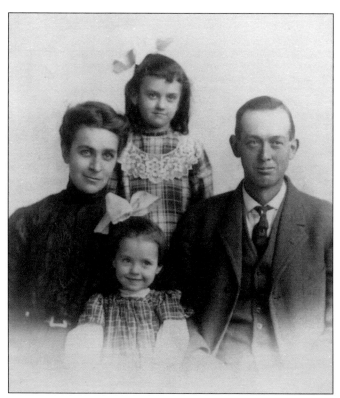

Anna and Newton Dominy are shown in the family photograph at left with their daughters Ruthella Termeer and Eleanor Lewis (standing); the couple is also pictured below. Newton, who was born on the family farm in Madison, Ohio, attended Hilliard High School before graduating from the Ohio Medical College. (Both courtesy of Laurie Termeer.)

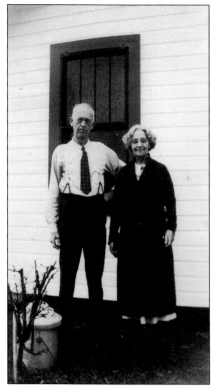

In this Dominy family photograph, Anna and Newton Dominy are surrounded by family members, clockwise from top left, Henry Albert Termeer Sr., Ruthella (Dominy) Termeer, Eleanor (Dominy) Lewis, Chuck Lewis, Charles Lewis, William Lewis, Patricia Lewis, Jerry Termeer, Henry Albert Termeer Jr., and Dick Termeer. (Courtesy of Laurie Termeer.)

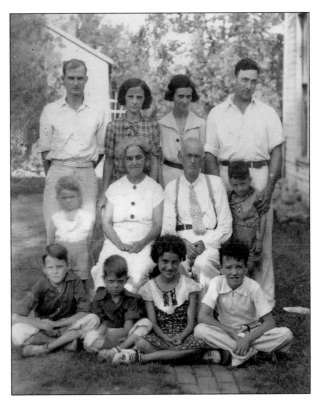

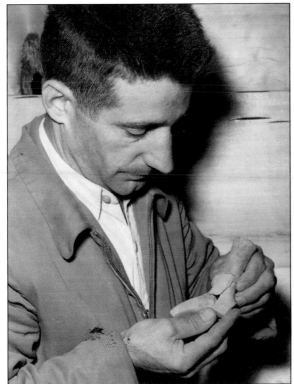

Raymond Baby, curator of archaeology for the Ohio Historical Society, examines pieces of an Adena pipe from a Dublin Road mound near Dublin on May 5, 1954. The Adena were one of several Native American tribes that once called Dublin home. (Courtesy of *Columbus Citizen*, Scripps-Howard Newspapers/Grandview Heights Public Library/Photohio.org.)

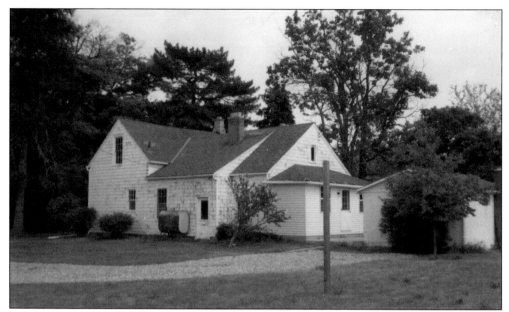

The home of Carrie and Frank Mitchell on Brand Road was located north of Dublin on the west side of the river near where Cardinal Health's headquarters is located today. In the 1970s, the home was restored to resemble what it would have looked like in the 1800s when it was first built. The photograph below shows the front parlor after the restoration. (Both courtesy of Ron Geese.)

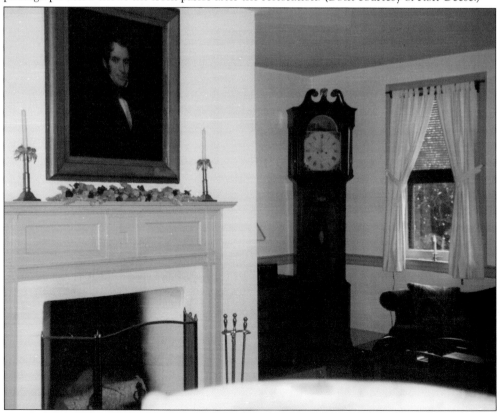

Frank and Carrie (Shriver) Mitchell sit outdoors with their daughters Helen (Geese) and Aleta (Watson) standing behind them at the Mitchell family home at 5565 Brand Road in the summer of 1956. (Courtesy of Ron Geese.)

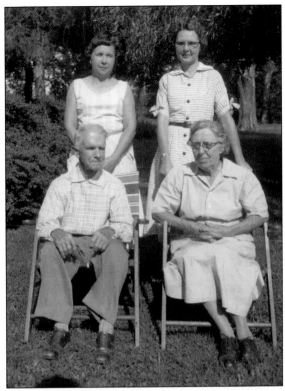

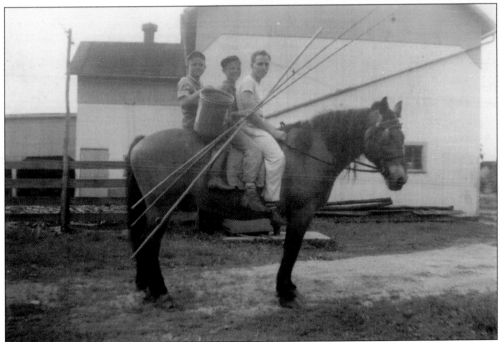

Leonard Tuller, at left, and John Geese, in front, carry bamboo fishing poles in June 1943. With the Scioto River nearby, fishing was a popular pastime, as was swimming in the river. They are shown in front of the Mitchell barn on Brand Road. (Courtesy of Ron Geese.)

Don Ashbaugh and Mary Alice Mitchell (pictured) married in 1928 and later divorced. Mary remarried in 1950 to James Elroy Leonard and had one son, Charles. (Courtesy of Ron Geese.)

Evelyn (Hall) Wirchainski grew up on a farm at Hall's Corner, near Post Road and Industrial Parkway. Her father, Lawrence Hall, also owned a 110-acre farm off Avery Road, which he eventually gave to Evelyn. In 1989, Evelyn sold the Avery Road farm to OhioHealth, which built Dublin Methodist Hospital on the site. (Courtesy of Ron Geese.)

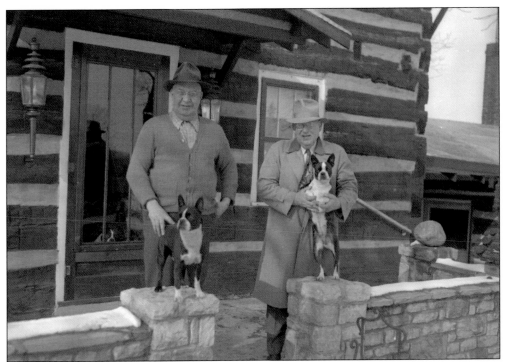

Two men pose with Boston terriers in front of the entrance to the Alexander Davis cabin at 5436 Dublin Road in Dublin in the 1940s. The cabin, built in 1812, was listed in the National Register of Historic Places in 1979. When the main house was razed, the cabin was disassembled and then reconstructed at Indian Run Falls Park. At the time of this photograph, Merrill L. Bigelow owned the home. (Herb Topy Collection/Courtesy of Columbus Jewish Historical Society.)

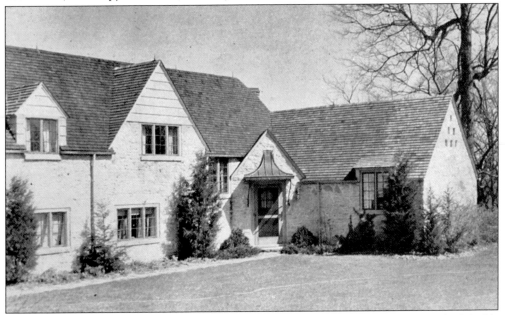

The 1940 home of Fred W. Weber, a salesman for the Ohio Wax Paper Co. who was married to Matilda Weber, showcases stone and gable architecture. (Courtesy of Columbus Metropolitan Library.)

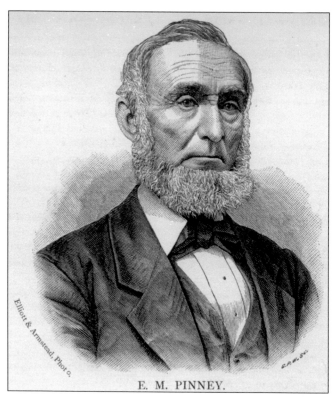

Dr. Eli Morrison Pinney began serving as Dublin's second physician in 1842. Like Dr. Chapman before him, he also married a Sells, Marilla, who was the granddaughter of John Sells. Dr. Pinney would not be the only doctor in the family. His great-grandson Henry Karrer would become a well-known general practitioner in Dublin responsible for delivering more than 1,000 babies in his time. (Courtesy of Dublin Historical Society.)

E. M. PINNEY.

Dr. Henry Karrer, grandson of one of Dublin's first doctors Eli M. Pinney, was a graduate of Dublin High School and received his medical degree from The Ohio State University in 1931. He is said to have been the attending physician for the births of the entire 1954–1955 Dublin High School basketball team. Today, Karrer Middle School at 7245 Tullymore Drive is named for the good doctor. He was inducted into the Dublin City Schools Alumni Association Hall of Fame in 2010. (Courtesy of Dublin Historical Society.)

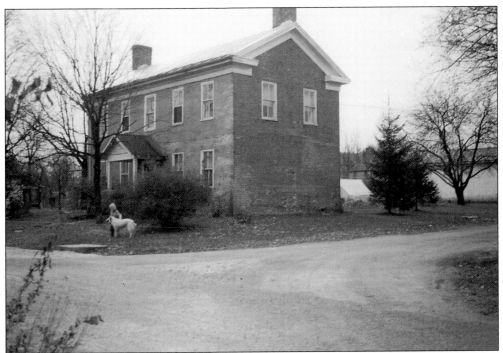

This Greek Revival brick home, located at 109 South Riverview Street, belonged to Dr. Eli M. Pinney and became a stop on the Underground Railroad. With its proximity to the Scioto River, slaves would hide in the bushes next to the house and talk to Dr. Pinney through a tube at the side of the home. He fed the slaves and let them sleep in his horse stable before they continued on their journey to Canada. Ohio State University professor Emmett Karrer, a descendant of George M. Karrer and a founding member of the Dublin Historical Society, is shown at right pointing at the tube. The home was built by Pinney's father-in-law Charles Sells in 1827 and was listed in the National Register of Historic Places in 1979. (Both courtesy of Dublin Historical Society.)

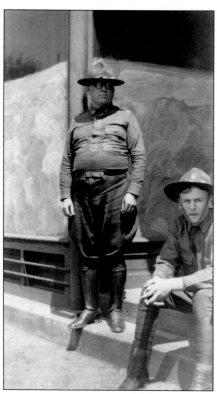

Dr. Harry Osborn began practicing medicine in Dublin in 1919 when Dr. Lewellyn McKitrick moved his practice to Worthington. Osborn, shown here in uniform on the left with an unidentified soldier, served in the medical corps during World War I. He was elected mayor of Dublin in 1926 and held the office until 1943. (Courtesy of Dublin Historical Society.)

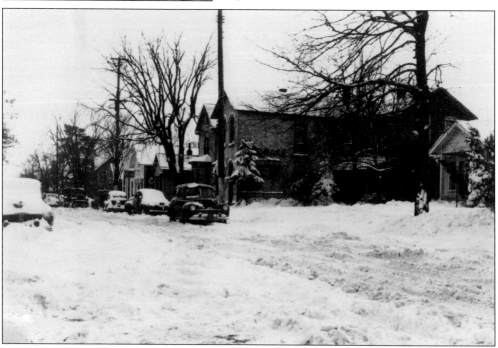

A freak snowstorm on Thanksgiving weekend of 1950 buried Dublin. The near-blizzard conditions dropped 20 inches of snow with drifts up to 25 feet deep. Cars were sidelined along High Street when residents found it too difficult to traverse the roadways. (Courtesy of Dublin Historical Society.)

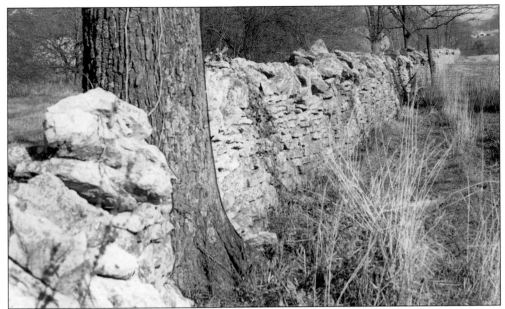

A stone fence, made of limestone from a nearby quarry, surrounds a pasture along Dublin Road in this photograph from November 23, 1952. The fences were used to prevent livestock from roaming around the countryside. Limestone fences like this have become an iconic symbol of Dublin and are used at many of its entryways. (Courtesy of *Columbus Citizen*, Scripps-Howard Newspapers/Grandview Heights Public Library/Photohio.org.)

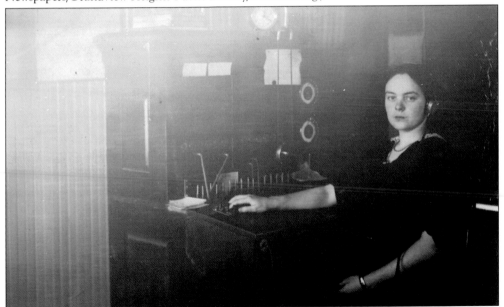

Switchboard operator Edith Rounbarger made telephone connections for the citizens of Dublin, who did not need a number to reach their party. A few years later, the system advanced with callers using two-letter exchanges. According to the Dublin Historical Society, Dublin telephone numbers were preceded by TU, short for Tulip, but later changed to Tuxedo. TU equated to 88 on the phone's dial pad. When exchanges were replaced with numbers, Dublin kept the 88, which is why many Dublin phone numbers still begin with the prefix 889. (Courtesy of Laurie Termeer.)

This 1933 high school graduation photograph shows John Geese. The Geese family emigrated from Germany in the early 1800s. In the early 1900s, William H. Geese and Charles O. Geese bought a farm on Sawmill Road. John was the youngest of William's eight children. Charles and his wife, Lule, had one daughter, Florence (Holder), and a son named Lewis who served as mayor of Dublin for two terms. Charles Geese owned a grocery store in Dublin from 1928 to 1936. (Courtesy of Carolyn Geese Herron.)

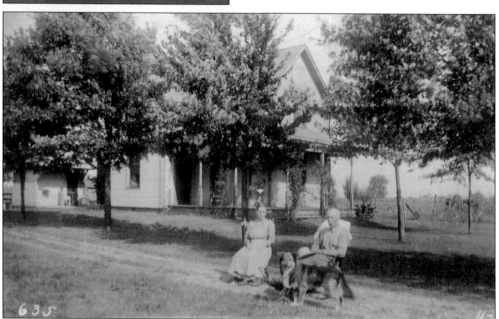

Slater and Hattie Mathias Shriver are pictured in front of a farm in Kileville. Located in Madison County, Kileville is an unincorporated village between Plain City and Dublin. (Courtesy of Carolyn Geese Herron.)

The Dublin Community Church, shown here in October 1956, includes a brick church built in 1877, which serves as the Washington Gladden Chapel. Gladden was the minister of the First Congregational Church in Columbus. Following the cyclone of 1912, the congregations of the Methodist Episcopalian, Christian, and Presbyterian churches merged as the Congregational Church in Dublin; today, it is known as Dublin Community Church. (Courtesy of *Columbus Citizen*, Scripps-Howard Newspapers/Grandview Heights Public Library/Photohio.org.)

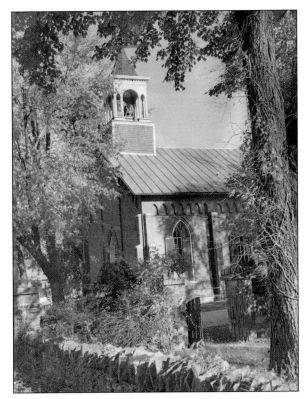

One of the city's main thoroughfares, the Bridge Street Bridge, seen here in 1984, provided access across the Scioto River. A modern four-lane bridge was dedicated in 1986. (Courtesy of *Columbus Citizen-Journal*, Scripps-Howard Newspapers /Grandview Heights Public Library/Photohio.org.)

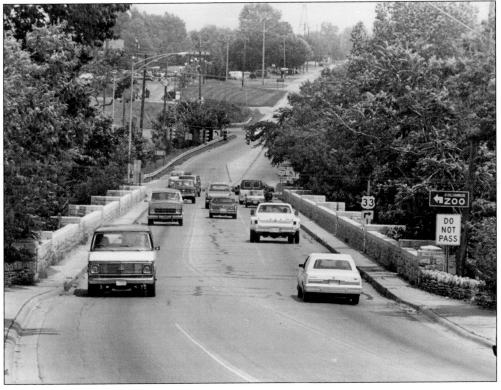

Laurie Termeer and her grandmother Ruthella (Dominy) Termeer are shown in a photograph published in the *Dublin Villager* in the 1980s. (Courtesy of Laurie Termeer.)

The Gasbarro Castle, located at 8024 Avery Road, was quite the conversation starter when Alio Gasbarro built it in 1974. Gasbarro made his fortune inventing a chicken-plucking machine that he sold to Colonel Sanders of Kentucky Fried Chicken fame. This photograph shows the palatial home on November 11, 1984. The house number has since changed to 8000, as new development occurred in the area. With more than 13,000 square feet, the home had an estimated value of $1.8 million in 2014. (Courtesy of *Columbus Citizen-Journal*, Scripps-Howard Newspapers/Grandview Heights Public Library/Photohio.org.)

Five

ATHLETIC PURSUITS

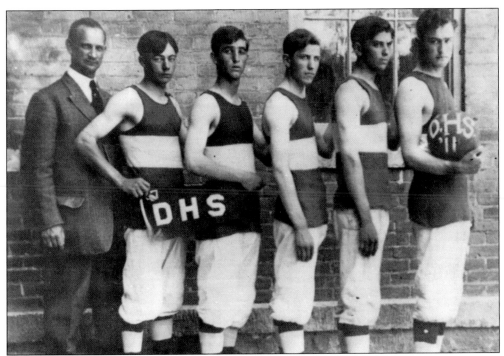

Members of Dublin High School's first basketball team pose in 1911. From left to right are coach Ralph Shilling, Harry Artz, Bid Snouffer, Ivan Wohrley, Henry Gordon, and Walter Smith. (Courtesy of Dublin Historical Society.)

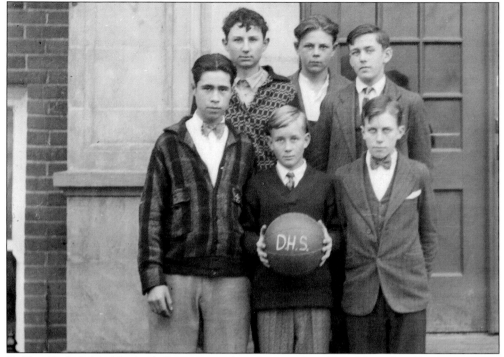

Dublin High School basketball team members pose at the old Dublin school building. Team members are, from left to right, (first row) Raymond Sutherland, Robert Larcamp, and John Geese; (second row) Laurence Mock, Cel Price, and Benson Wheeler. (Courtesy of Ron Geese.)

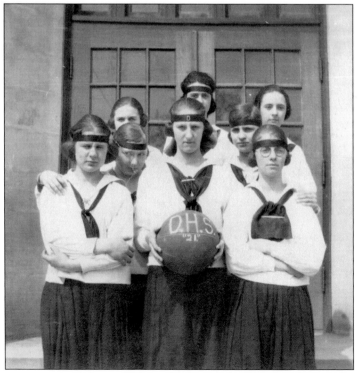

Girls were allowed to play on basketball teams at Dublin High School beginning in 1921. Their uniform consisted of red flannel bloomers, long underwear, socks, a white blouse, and a large bow, a style common to most girls' basketball teams in the 1920s. From left to right are (first row) Florence Sells, Pauline Leppert, and Helen Gease; (second row) Lola Wilcox, Anna Mae Horch, Eleanor Dominy, Sara McCoy, and Ruthella Dominy. (Courtesy of Dublin Historical Society.)

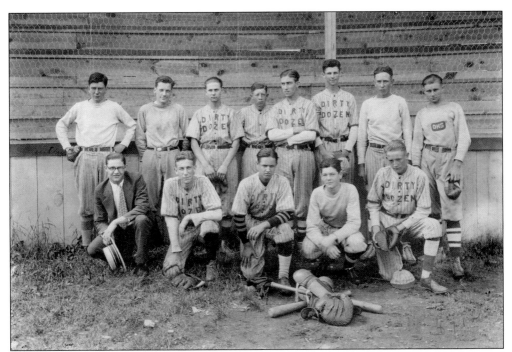

Summer baseball leagues featured some rowdy individuals, including one team that called themselves the Dirty Dozen. Here, the 12 teammates and their coach take a break from playing in 1929. (Courtesy of Dublin Historical Society.)

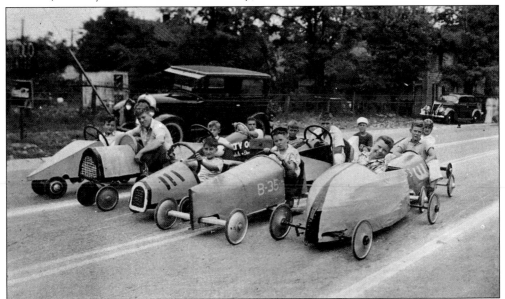

In 1939, Dublin boys and a few out-of-towners gathered to race in a soapbox derby. Dublin's entries included Dick Hill, George Windell, Carl Hill, Dave Perly, Don Eberly, Bob Eberly, and Charlie Wolpert. Soapbox derbies were a popular pastime in the 1930s. Boys competed in homemade cars powered by gravity. The first All-American Soapbox Derby was held in Dayton in 1933 and became such a huge success that it was moved to Akron in 1935 with support from that town's rubber industry. (Courtesy of Dublin Historical Society.)

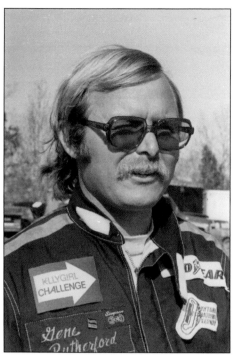

Race car driver Gene Rutherford, a Dublin resident, drove an Oldsmobile Cutlass in the 1979 International Motorsports Association's Kellygirl Challenge held at Mid-Ohio Raceway in Lexington, Ohio. (Courtesy of *Columbus Citizen-Journal*, Scripps-Howard Newspapers/Grandview Heights Public Library/Photohio.org.)

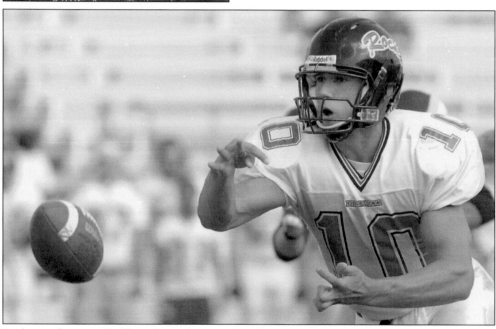

In the modern era, Dublin schools have produced quite a few major league athletes, including former Cincinnati Reds pitcher Kent Mercker, former Green Bay Packers running back Vince Workman, and the NFL's Brady Quinn (pictured). Quinn, who quarterbacked the Dublin Coffman Shamrocks, graduated in 2002 and then played for the Fighting Irish of Notre Dame. He was drafted by the Cleveland Browns in the first round of the 2007 NFL draft and has also played for the Denver Broncos, Kansas City Chiefs, Seattle Seahawks, New York Jets, St. Louis Rams, and Miami Dolphins. (Courtesy *Dublin Villager.*)

Six

EXCELLENCE IN EDUCATION

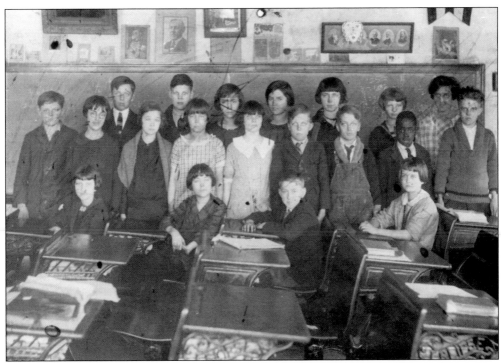

Johnny Geese's fifth-grade class of 1923 included, from left to right, (first row) Mary Thompson, Elizabeth Weber, Luther Karrer, and Florence Pinney; (second row) Helen Jane Smith, Aleta Mitchell, Beulah Butts, Opal Penn, Johnny Geese, Jimmy McCoy, Louis Sutherland, and Aaron Sharp; (third row) Benson Wheeler, Robert Brown, Anna Partlow, Thelma Dozier, Alice Jennings, Ruth Fairchild, Louise Hofner, and Celmon Price. (Courtesy of Ron Geese.)

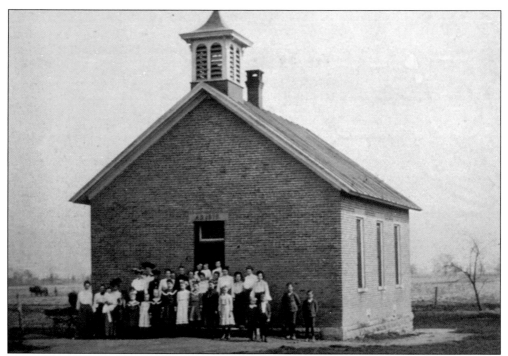

One of the Dublin area's earliest school buildings, the McDowell School was built in 1878. (Courtesy of Dublin Historical Society.)

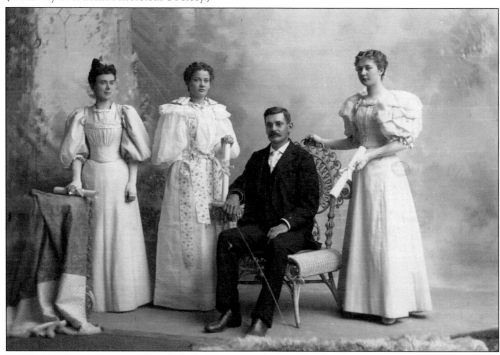

Dublin's first graduating class included four members in 1892. The commencement ceremony was held over two evenings, May 4 and 5, at the Christian Church. The invitation stated, "The Public School – The Hope of the Country." (Courtesy of Dublin Historical Society.)

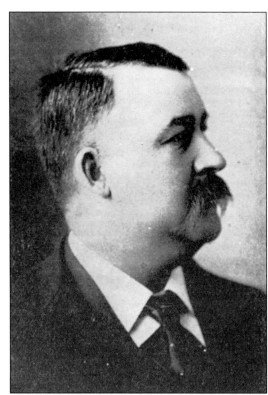

Ira W. Brownfield, pictured at right in 1896, was superintendent of Dublin schools before becoming a Columbus realtor in 1891. Willard Grizzell, pictured below in 1982, held a variety of jobs—all in education. He was named superintendent of Dublin City Schools in 1961, following a career as a science and math teacher, high school counselor, and football coach. Grizzell Middle School was named in his honor in 1994. (Right, courtesy of Columbus Metropolitan Library; below, courtesy of *Columbus Citizen-Journal*, Scripps-Howard Newspapers/Grandview Heights Public Library/Photohio.org.)

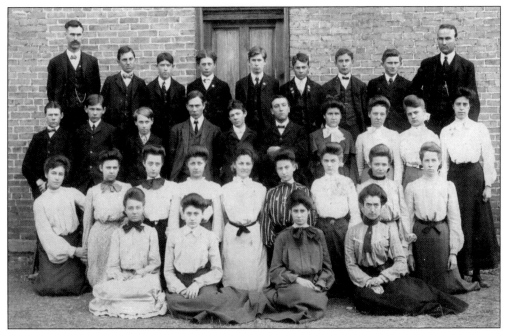

Carrie Mitchell Shriver's high school graduating class is shown in this photograph from 1883. Carrie is in the third row, third from the right. The class is posing in front of the door of the Washington Township School, which eventually became the Odd Fellows lodge. (Courtesy of Carolyn Geese Herron.)

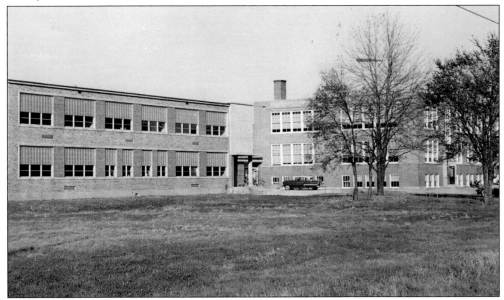

When a new school building was constructed in 1919, it included grades 1–12. By 1945, it became apparent that the school would need to be expanded. The planned addition would include a gymnasium and two classrooms, but construction was delayed after the war began. The addition was eventually dedicated in 1952. This photograph shows the addition at the left of the main building in 1956. (Courtesy of *Columbus Citizen*, Scripps-Howard Newspapers/Grandview Heights Public Library/Photohio.org.)

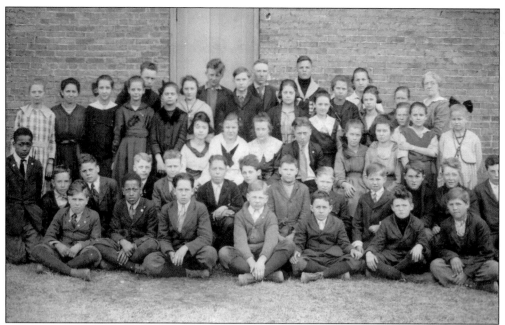

The sixth, seventh, and eighth grades gathered for this 1919 photograph. This was the last year students would attend the Washington Township School on North High Street. (Courtesy of Laurie Termeer.)

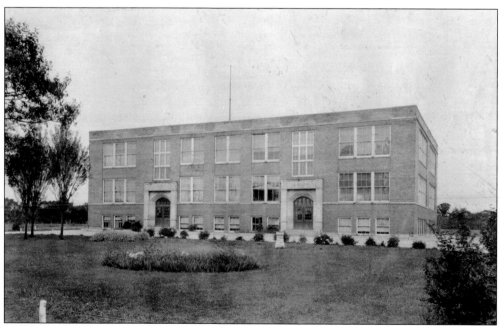

Children in grades 1–12 attended school at 144 West Bridge Street; the 25,500-square-foot building was dedicated on December 31, 1919, and cost $52,500 to build. The new school brought together students from Dublin Precinct, Dublin Corporation, Perry Township, and Amlin under one roof. Now known as the 1919 Building, it is still in operation today as part of Sells Middle School. (Courtesy of Dublin Historical Society.)

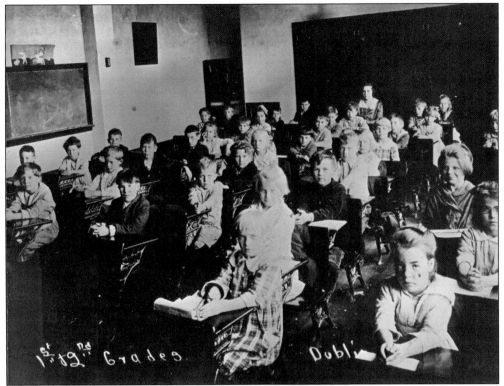

In 1920, first- and second-graders in Dublin posed for this portrait at their new school at 144 West Bridge Street. (Courtesy of Columbus Metropolitan Library.)

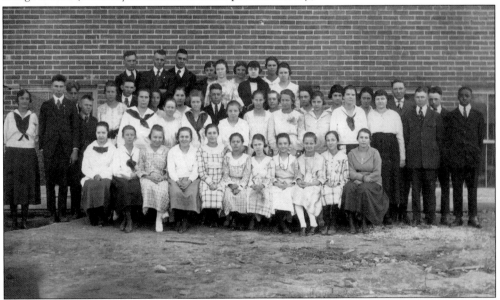

The Dublin High School graduation class of 1920 is pictured here. This is the first year they attended school in the new building. Prior to 1920, classes were held in a three-story building called the Washington Township School, which was located where the Dublin branch of the Columbus Metropolitan Library is today. (Courtesy of Laurie Termeer.)

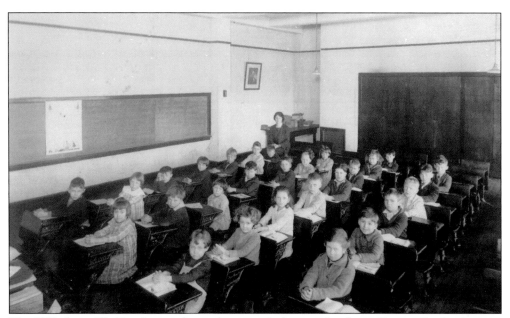

The 1922 class of Dublin first-graders is shown with their teacher Jessie Shriver. Students are, in unknown order, Irene Smiley, Glenn Henson, Reuben Wheeler, Ray Brown, ? McGuire, Esther Hare, Robert Tuller, Judson Harmon, Edgar Fairchild, Aldeus Thompson, Ella Mae Smith, Helen Mitchell (Geese), James Thompson, Milton Smiley, Dorothy Brown, Dorothy Partlow, Mary Sells, Richard Myers, Henry Louis Coffman, Eda Mary Harmon, Morgan Wright, and Richard Myers. In 1952, Helen Mitchell Geese's son Ron would sit in the same desk in the same classroom for first grade. (Courtesy of Ron Geese.)

The Dublin High School class of 1923 held its 10th reunion in 1933. Nine members of the class turned out for the event at the Miller farm. Ruthella (Dominy) Termeer is second from the left in the front row. (Courtesy of Laurie Termeer.)

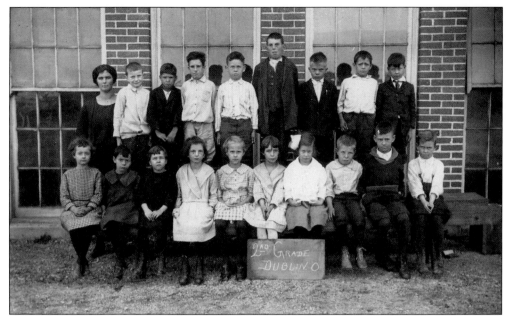

Dublin's second-grade class of 1923 included, in unknown order, Ralph Williams, Glenn Henson, Judson Harmon, Ray Brown, Wilson Pendeleton, Edgar Fairchild, Benjamin Hare, Milton Smiley, Robert Tuller, Reuben Wheeler, James Thompson, Irene Smiley, Dorothy Partlow, Florence Rigel, Aldena Thompson, Helen Mitchell (Geese), Esther Hare, and Ella Mae Smith. Their teacher Arvilla Geese is pictured with the students. (Courtesy of Ron Geese.)

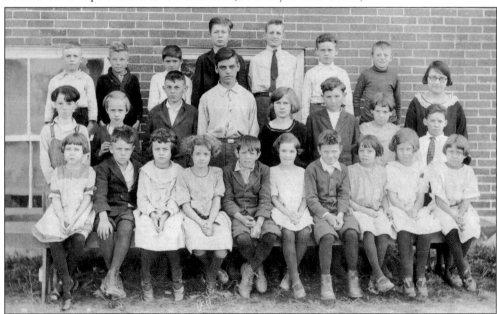

Dublin third-graders, posing with their teacher Miss Moffitt in 1924, are, in unknown order, Paul Morgan, James Thompson, Glenn Henson, Lawrence Rockenbaugh, Milton Rockenbaugh, Ray Brown, Ralph Williams, Beatrice Pendleton, Lawrence Mock, Helen Rockenbaugh, Alfred Lake, Florence Rigel, Walter Hayes, Eulalia Billingsley, Ella Mae Smith, Benjamin Hare, Virginia V., Milton Smiley, Esther Hare, Irene Smiley, Mabel H., and Helen Mitchell (Geese). (Courtesy of Ron Geese.)

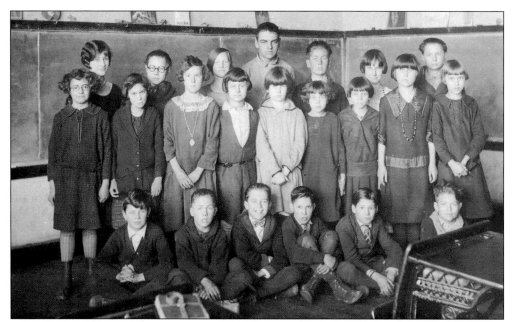

Dublin's fourth-grade class of 1925, shown with their teacher Miss Groves, included, in unknown order, Helen Mitchell (Geese), Lawrence Mock, Frances Cappell, Lawrence Rockenbaugh, Alfred Lake, Margaret Garling, James Riedmiller, Ella Mae Smith, Beulah Gordon, Beatrice Pendleton, Eulalia Billingsley, Irene Smiley, Esther Hare, Helen Rockenbaugh, Florence Rigel, Walter Myers, Glenn Henson, Herbert Datz, Noah Hall, Paul Morgan, and Milton Smiley. (Courtesy of Ron Geese.)

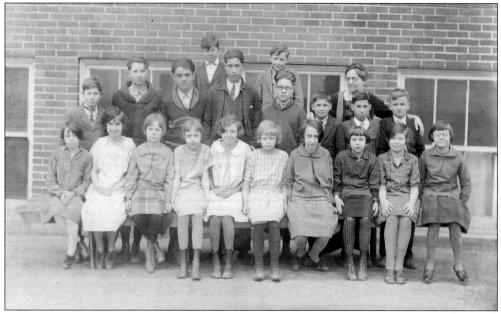

The 1926 class of fifth-graders, taught by Nel Tuller, included, in unknown order, Helen Mitchell (Geese), Junior Stricken, Milton Smiley, John Moffitt, Lawrence Mock, Alfred Lake, Raymond Sunderland, Glenn Henson, Herbert Datz, Charles Brobeck, Eulalia Billingsley, Irene Smiley, Vera ?, Irene Blanton, Beatrice Pendleton, Florence Riegel, Doris Cruse, Frances Cappell, and Esther Hare. (Courtesy of Ron Geese.)

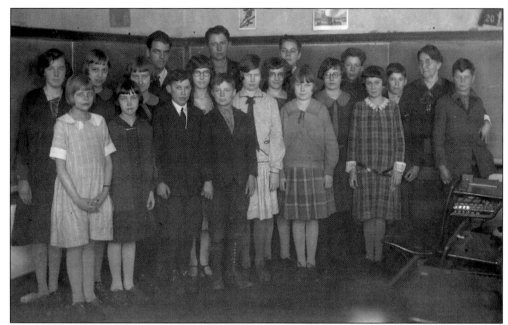

Posing for this photograph on June 18, 1927, is Dublin's sixth-grade class. Students are, in unknown order, Louise Deley, Milton Smiley, Beulah Gordon, Doris Cruse, Irene Smiley, Junior Stricklin, Herbert Datz, Helen Mitchell (Geese), Irene Blanton, Beatrice Pendleton, Florence Rigel, Lucille Wolpert, Frances Cappell, Ella Mae Smith, Eulalia Billingsley, Glenn Hinson, John Moffitt, James Riedmiller, Lawrence Mock, Alfred Lake, and Raymond Sunderland, with teacher Nel Tuller. (Courtesy of Ron Geese.)

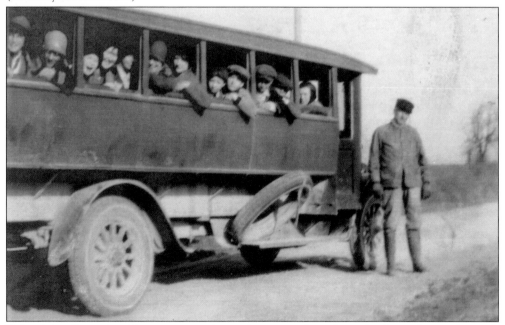

Before big yellow school buses came to be, students were ferried to school on a bus with wood-rimmed wheels. This group from 1929 prepares for the trek to the 1919 Building. (Courtesy of Dublin Historical Society.)

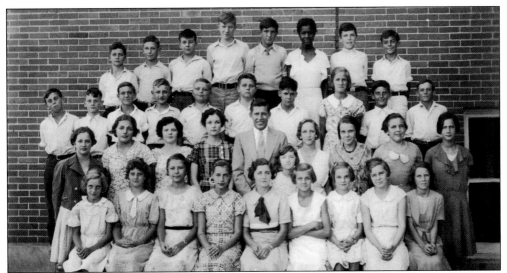

Dorothy Margaret "Doris" Sutherland Chever (fourth row, third from right) was born on October 9, 1921, and grew up on Sawmill Road, then called Middle Road. The daughter of Sylvester Delois Sutherland and Myrtle Neola Grimes, she grew up with five brothers and sisters. The Sutherlands were the only African Americans at the school when Doris attended. Known as the best speller in the school, she also was chosen to be her class historian. Chever eventually moved to Cranston Drive, not far from where she grew up. (Courtesy of Columbus Metropolitan Library.)

This photograph from 1956 shows Dublin's first high school, which was known as the Washington Township School. Built in 1871, the building was three stories tall and located on North High Street. It served the community until the construction of the 1919 Building on Bridge Street, which housed all grades until the 1950s. (Courtesy of Columbus Citizen, Scripps-Howard Newspapers/ Grandview Heights Public Library/Photohio.org.)

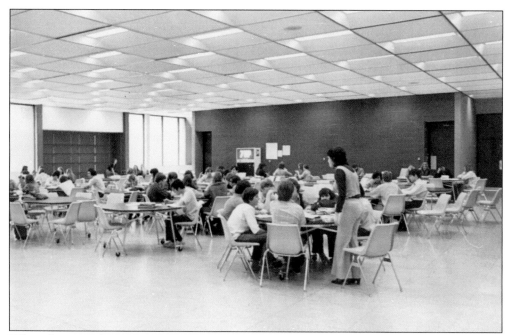

When the expanding community needed a new high school, the school board made its case for the need to buy 50 acres. Following a successful levy campaign, the new high school was built on Coffman Road and opened in 1973. The dining room at the school, now known as Dublin Coffman, was state-of-the-art. (Courtesy of *Columbus Citizen-Journal*, Scripps-Howard Newspapers/ Grandview Heights Public Library/Photohio.org.)

The newly constructed Dublin High School opened on January 2, 1973. When the district expanded again, first adding Scioto and then Jerome High Schools, this building was renamed Dublin Coffman. The three schools' mascots carry on the Irish theme with Coffman's Shamrocks, Scioto's Irish, and Jerome's Celtics. All three incorporate green and white as their colors, with Coffman adding black, Scioto adding silver, and Jerome gold. (Courtesy of *Columbus Citizen-Journal*, Scripps-Howard Newspapers/Grandview Heights Public Library/Photohio.org.)

Seven

A SENSE OF PLACE

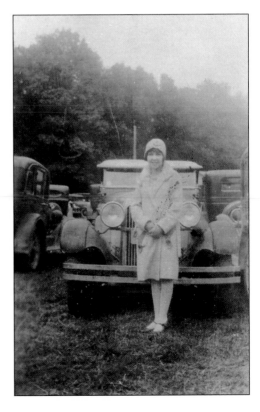

A popular nearby outing was the Hilliards Fair. Teenager Helen Mitchell (Geese) visited the fair in 1929, as shown in a photograph taken by her friend Eulalia Billingsley Frantz. Today, the Franklin County Fair is held annually at the fairgrounds in Old Hilliard. (Courtesy of Ron Geese.)

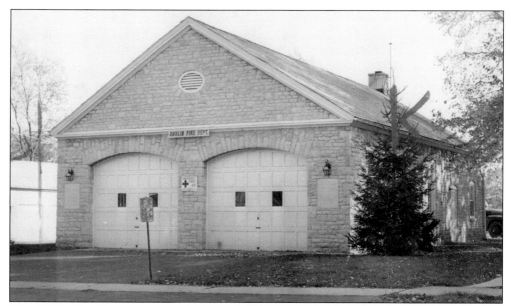

The Dublin Fire Department is seen here in 1956. Dublin's first firehouse was built in 1944 at 37 Bridge Street and was shared by Washington and Perry Townships until Perry relocated to Sawmill Road. The Washington Township Fire Department continues to serve the entire city of Dublin today. (Courtesy of *Columbus Citizen*, Scripps-Howard Newspapers/Grandview Heights Public Library/Photohio.org.)

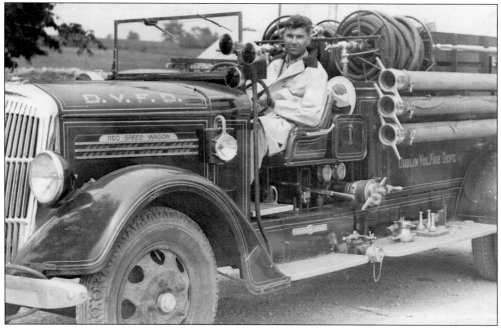

In addition to serving as fire chief of Dublin, James Moffitt, pictured in 1941, also was the town marshal and a mechanic at the Brown-Thomas Garage on Riverside Drive, where the fire department frequently stored Dublin's first fire truck, a 1937 Reo Seagrave combination 500-gallon pumper and hose car. (Courtesy of *Columbus Citizen*, Scripps-Howard Newspapers/Grandview Heights Public Library/Photohio.org.)

James Moffitt, pictured in 1943, served as fire chief of Dublin in Perry Township. He was one of seven original members of the Dublin Volunteer Fire Department. Other members were Assistant Chief Harold Shriver, Capt. Henry Albert Termeer Sr., Albert Smith, Henry L. Coffman, and Don Ashbaugh. (Courtesy of *Columbus Citizen*, Scripps-Howard Newspapers/Grandview Heights Public Library/Photohio.org.)

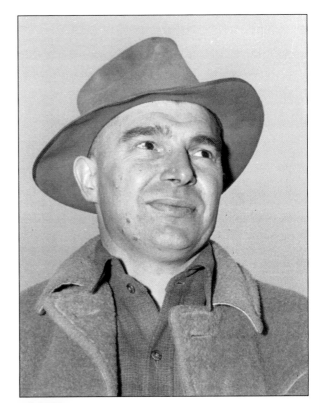

When Ruthella Dominy was a child, her father operated the post office from 27 South High Street. Following him was postmaster Dora Krouse. She moved the post office to her grocery store at 32 South High Street. When Ruthella, who married Henry Albert Termeer, took over, she moved it back to 27 South High Street where it operated from 1955 to 1965. Today, the building is the location of the Dublin Village Tavern. (Courtesy of Dublin Historical Society.)

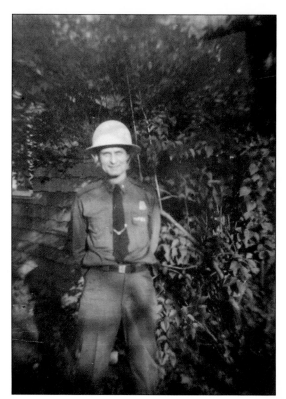

Henry Albert Termeer Sr. prepares to take shelter for an air raid drill during World War II. Henry married Ruthella Dominy in 1925. Ruthella would become postmaster for Dublin following in the footsteps of her father, Newton Dominy. Al and Ruthella had five children, Henry Albert Jr., Jerry, Richard, Gary, and Larry. The couple died 36 hours apart in November 1983. (Courtesy of Laurie Termeer.)

Ralph Jones was elected mayor of Dublin in 1956 and served for one term. The village continued to operate as a strong mayor form of government until a village manager was hired in 1972. (Courtesy of *Columbus Citizen-Journal*, Scripps-Howard Newspapers/Grandview Heights Public Library/Photohio.org.)

Sherm Sheldon, pictured in 1980, was Dublin's first village manager. Hired in 1972 to manage the village's day-to-day affairs, he previously served on Dublin Village Council from 1962 to 1968. An avid fisherman, the city named a fishing derby for him. The event takes place annually as part of the Independence Day festivities. (Courtesy of *Columbus Citizen-Journal*, Scripps-Howard Newspapers/Grandview Heights Public Library/Photohio.org.)

Dublin fire chief Henry Albert Termeer Sr., born on August 23, 1905, to George and Nellie Termeer, is shown in a tintype photograph. He married Ruthella Dominy on May 14, 1925. His son Gary would follow in his footsteps as Washington–Perry Township fire chief. (Courtesy of Laurie Termeer.)

Dublin postmaster Ruthella (Dominy) and Dublin fire chief Henry Albert Termeer Sr. were the parents of five sons, Henry Albert Jr., Jerry, Richard "Dick," and twins Gary and Larry; Gary's twin, Larry, died when he was just one day old. Pictured with their parents are, from left to right, Henry Albert Jr., Dick, Gary, and Jerry. The Termeer boys were well known in the neighborhood today known as Historic Dublin. Henry Jr., who was known as Albert, was the area's paperboy before passing the responsibility along to his brother Jerry, who turned it over to Dick before youngest brother Gary took over. (Courtesy of Laurie Termeer.)

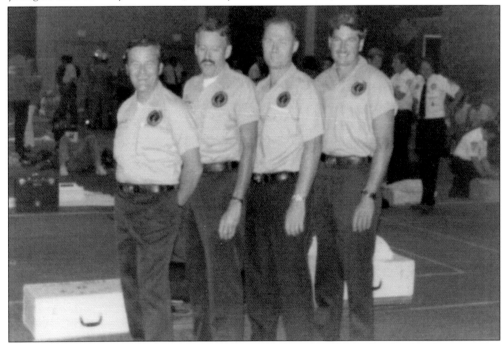

Dublin firefighters were named world champions at the 1973 Fire-Rescue International competition sponsored by the International Association of Fire Chiefs. The team included Bob Cashell, Johnny Brown, Chief Gary Termeer, and Larry Hall. (Courtesy of Laurie Termeer.)

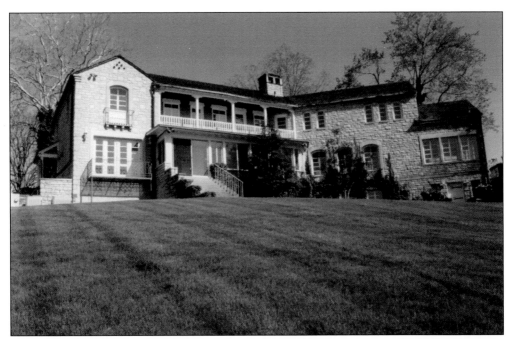

The home of the Dublin Arts Council, 7125 Riverside Drive, was originally built in 1941 for Charles and Sarah Krumm. The French Eclectic style was patterned after a stone Norman-style home that the Krumms became enamored with on a trip to France in the late 1930s. In 1947, Andre and Eleanor Gelpi, the founder of Swan Cleaners, bought the home, where they hosted many fundraisers and social events, including an annual Fourth of July party complete with its own fireworks display. Through the years, the home is said to have been visited by Audrey Hepburn, Jayne Mansfield, Perry Como, and many distinguished politicians. (Both courtesy of Dublin Arts Council.)

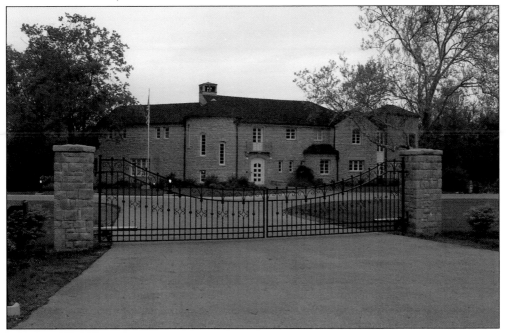

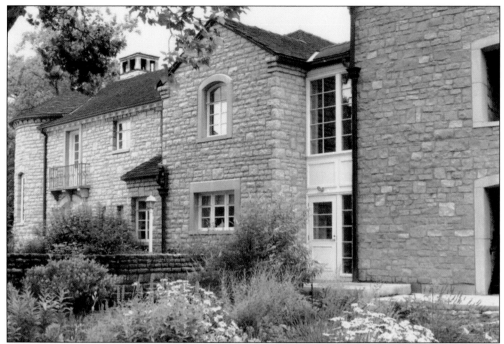

In 1999, the City of Dublin purchased the home at 7125 Riverside Drive from arts philanthropist Eleanor Gelpi to create the Dublin Arts Center. The building, located on the banks of the Scioto River, now houses the Dublin Arts Council and features art galleries, classrooms, meeting rooms, and a gift shop. (Both courtesy of Dublin Arts Council.)

Eight

JACK NICKLAUS
DISCOVERS DUBLIN

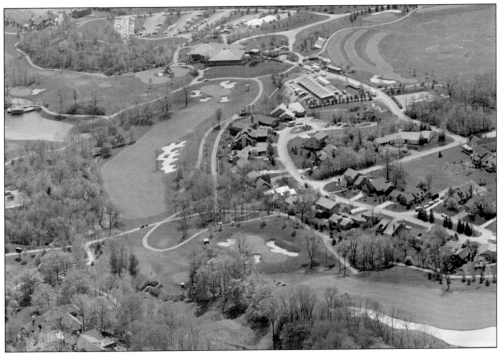

When Jack Nicklaus decided to build a golf course in Dublin where the Memorial Tournament would eventually be played, he was advised to include a residential development as part of the project. Muirfield Village, encompassing nearly 4,000 acres, was designed to connect neighborhoods via bike paths with the recreation areas, local schools, and the center of the village, while maintaining the parklike environment of the community. (Courtesy of *Columbus Citizen-Journal*, Scripps-Howard Newspapers/Grandview Heights Public Library/Photohio.org.)

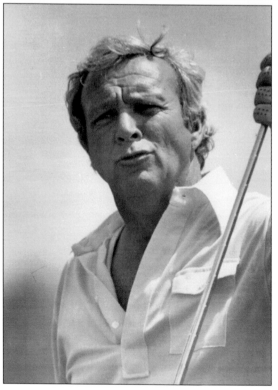

The new clubhouse at Muirfield Village Golf Club was unveiled on New Year's Eve 1975. The following May, the inaugural Memorial Tournament was played on the course with 1975 Professional Golfers' Association (PGA) Tour Rookie of the Year Roger Maltbie winning the $40,000 first prize. Because of Jack Nicklaus's precise attention to detail, the Memorial Tournament is said to be one of the players' favorites on the PGA Tour. (Courtesy of *Columbus Citizen-Journal*, Scripps-Howard Newspapers/Grandview Heights Public Library/Photohio.org.)

Each year, the Memorial Tournament attracts the PGA Tour's top players and some of the legends of golf. In 1980, Arnold Palmer played the course. In 1993, he returned as the honoree of the tournament. During his career, he won 92 championships. (Courtesy of *Columbus Citizen-Journal*, Scripps-Howard Newspapers /Grandview Heights Public Library/Photohio.org.)

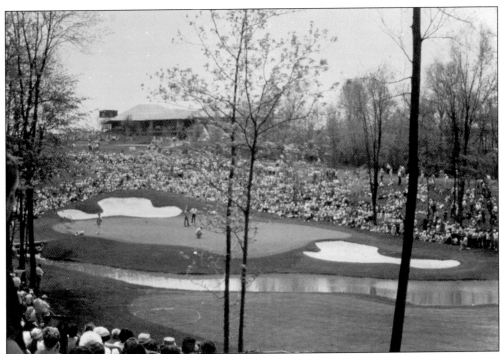

With the clubhouse in view, the gallery expands for a chance to watch leading golfers compete on the course that Jack Nicklaus built. Despite inclement weather throughout the week, Tom Watson emerged victorious at the 1979 Memorial Tournament. Watson returned in 1983 and is shown below playing a bunker on the 18th hole. He placed 20th that year with Hale Irwin taking top honors. Watson was the tournament's honoree in 2012. (Both courtesy of *Columbus Citizen-Journal*, Scripps-Howard Newspapers /Grandview Heights Public Library/Photohio.org.)

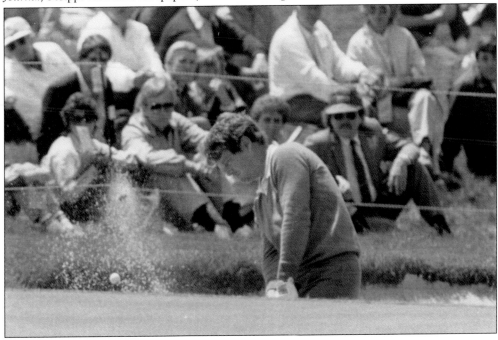

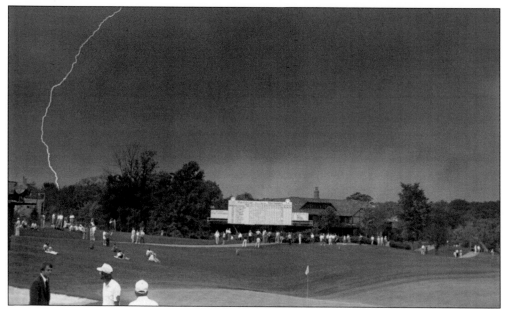

Play is about to be suspended on May 28, 1982, as lighting appears over the Memorial Tournament. Throughout its history, the tournament has been plagued by bad weather. Someone once suggested that it was the curse of Chief Leatherlips, who was executed for practicing witchcraft. In an effort to appease Leatherlips—and the weather gods—Barbara Nicklaus, wife of Jack, left a glass of gin at the chief's burial site. Despite her effort, play has continued to be suspended by the Midwest's rainy spring weather through the years, and most spectators now know to wear their rain gear. (Courtesy of *Columbus Citizen-Journal*, Scripps-Howard Newspapers/Grandview Heights Public Library/Photohio.org.)

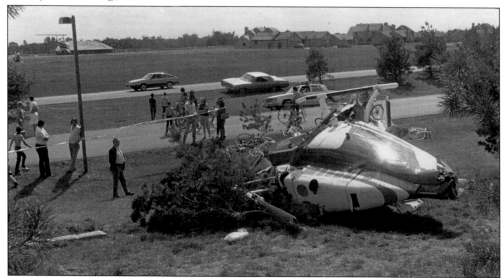

Golf is big news during the week of the Memorial Tournament, but it was what happened off the course that made headlines on September 4, 1982. Thankfully, no major events were taking place on the course when a helicopter crashed along Muirfield Drive. The clubhouse is visible in the distance. (Courtesy of *Columbus Citizen-Journal*, Scripps-Howard Newspapers/Grandview Heights Public Library/Photohio.org.)

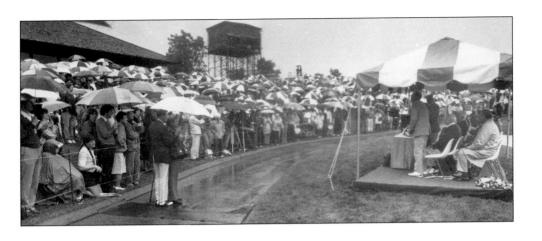

Each year, the Memorial Tournament honors an individual who has contributed to the game of golf. Honorees are selected by the Captain's Club, which includes past presidents, golfing legends, actors, and men and women in business. In 1983, Tommy Armour was named honoree for the tournament. In the 1920s and 1930s, Armour won the US Open, the PGA Championship, the British Open, three Canadian Opens, and the 1928 Western Open. (Both courtesy of *Columbus Citizen-Journal*, Scripps-Howard Newspapers/Grandview Heights Public Library/Photohio.org.)

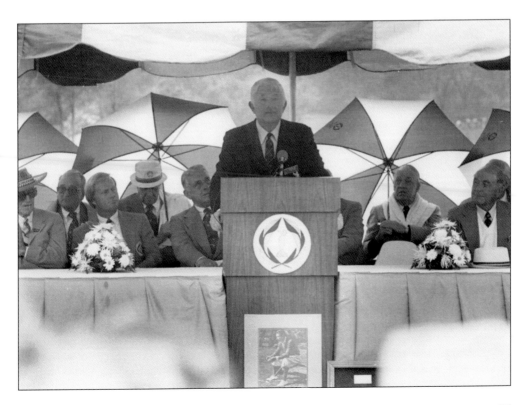

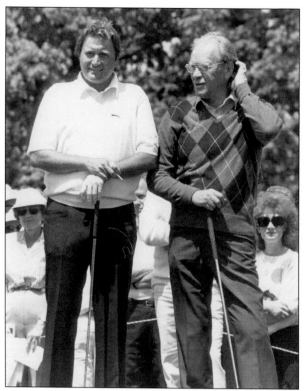

Professional golfer Ray Floyd chats with former president Gerald Ford while waiting to begin the 1983 Pro-Am event at the Memorial Tournament. Floyd was the winner of the tournament in 1982. Throughout the years, the Pro-Am has attracted dignitaries and celebrities, including actor Sean Connery, who is a member of the Captain's Club, which annually chooses that year's honoree. (Both courtesy of *Columbus Citizen-Journal*, Scripps-Howard Newspapers/Grandview Heights Public Library/Photohio.org.)

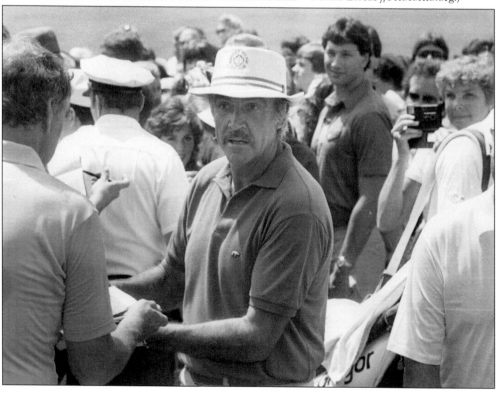

Actor and comedian Bob Hope celebrated his 80th birthday at the 1983 Memorial Tournament. Hope was taking part in the Pro-Am prior to the tournament's official start. (Courtesy of *Columbus Citizen-Journal*, Scripps-Howard Newspapers /Grandview Heights Public Library/Photohio.org.)

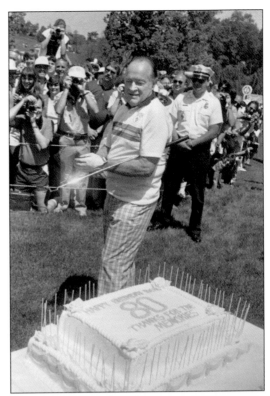

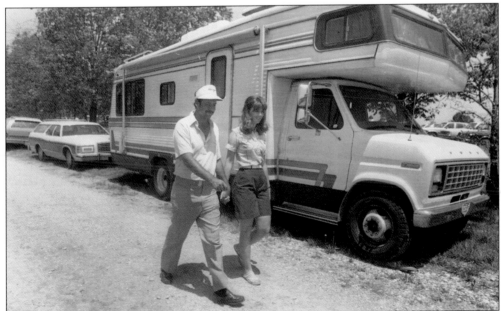

Professional golfers follow their own routines while on tour. While some prefer hotels, others have requested private residences and have become like family to residents of Muirfield Village, who open their homes to the golfers and their families for the Memorial Tournament. In 1983, golfer Brad Bryant and his wife, Sue, chose to stay in a camper for the week. (Courtesy of *Columbus Citizen-Journal*, Scripps-Howard Newspapers/Grandview Heights Public Library/Photohio.org.)

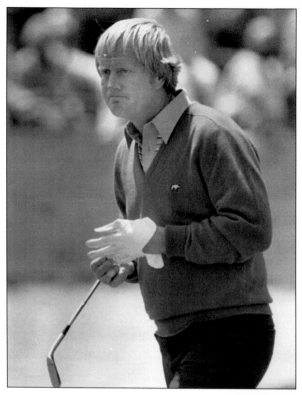

Legendary golfer and Central Ohio native Jack Nicklaus takes great pride in the Muirfield Village Golf Club that he helped design and build. At the 1983 Memorial Tournament, his son Jack Jr. played caddy for his dad. Nicklaus placed 35th that year; Hale Irwin won the $72,000 purse for first place. Nicklaus has won the tournament twice, in 1977 and 1984. (Both courtesy of *Columbus Citizen-Journal*, Scripps-Howard Newspapers/Grandview Heights Public Library/Photohio.org.)

Lee Trevino prepares to putt at the 1983 Memorial Tournament. Trevino, who won six major championships in his career, was the 2004 honoree along with Joyce Wethered. Trevino is one of four players to twice win the US Open, the Open Championship, and the PGA Tournament. (Courtesy of *Columbus Citizen-Journal*, Scripps-Howard Newspapers /Grandview Heights Public Library/Photohio.org.)

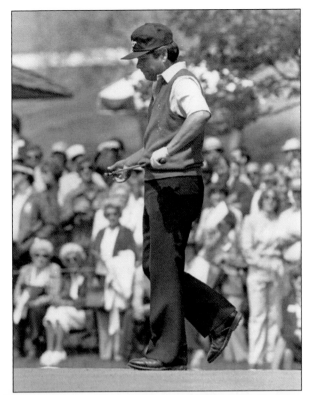

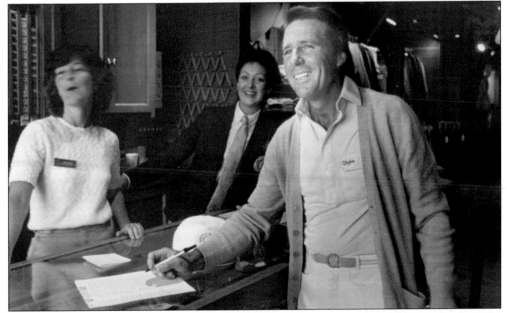

South African golfer Gary Player signs autographs as he arrives at the clubhouse for the 1983 Memorial Tournament. Player is the winner of nine major championships on the regular tour and six Champions Tour majors and was the 1997 Memorial Tournament honoree. In 1965, he became the only non-American to win all four majors, known as a Grand Slam. (Courtesy of *Columbus Citizen-Journal*, Scripps-Howard Newspapers /Grandview Heights Public Library/Photohio.org.)

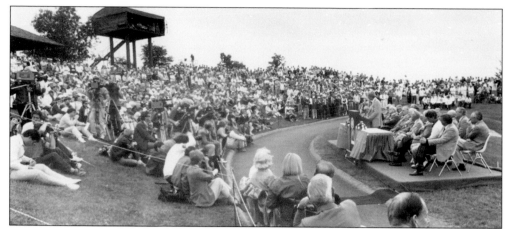

Jack Nicklaus addresses golfing fans gathered for the honoree ceremony. Each year, the PGA Tour Memorial Tournament pays tribute to one of golf's greats. In 1985, the honoree was Charles "Chick" Evans, winner of the 1916 US Open and US Amateur championships, and namesake for the Evans Scholars Foundation. (Courtesy of *Columbus Citizen-Journal*, Scripps-Howard Newspapers /Grandview Heights Public Library/Photohio.org.)

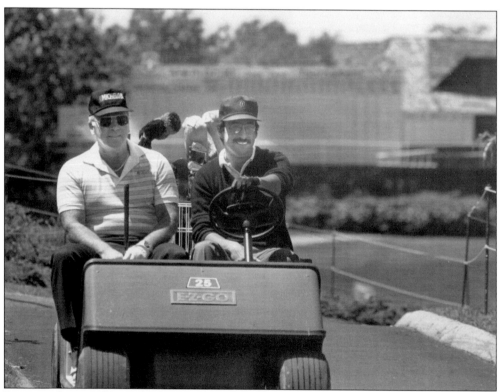

Race car driver Bobby Rahal takes a lap in a golf cart at the 1985 Pro-Am prior to the start of the 1985 Memorial Tournament. In the cart with Rahal is his golf partner Tom Tramski. (Courtesy of *Columbus Citizen-Journal*, Scripps-Howard Newspapers /Grandview Heights Public Library/Photohio.org.)

Nine

CELEBRATING THE CITY

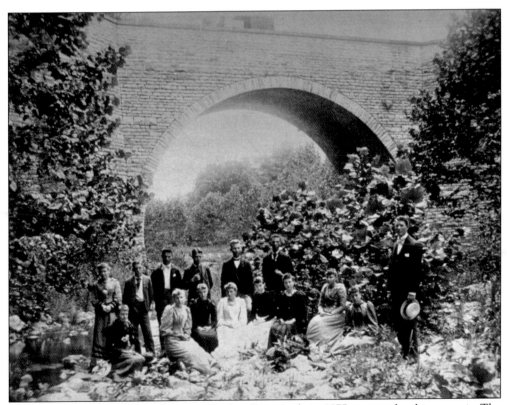

Early Dubliners gathered at the scenic Indian Run Arch in 1875 to pose for this portrait. The stone arch bridge connected North High Street to Dublin Road. Built in 1873, it was the largest stone arch bridge in Ohio, but it was removed in 1950. (Courtesy of Dublin Historical Society.)

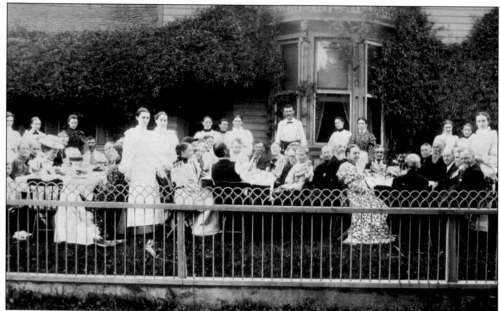

T.J. Steinbower, who was elected mayor of Dublin in 1881, hosted the members of the Dublin Ladies' Aid Society for a luncheon at his home in the late 1800s. Ladies' aid societies were organized during the Civil War to provide supplies to soldiers on the battlefield. They also would care for sick and wounded soldiers. The aid societies often held social functions to collect donations to fund their work. (Courtesy of Dublin Historical Society.)

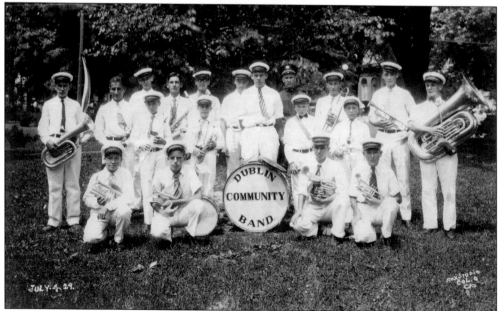

The Dublin Community Band was first organized in 1926 following the popularity of the Dublin Cornet Band, which played at community celebrations from 1879 to 1939. The community band, under the direction of Harry Hirt, is shown on July 4, 1929. The original cornet band enjoyed such great success that it was revived for the city's bicentennial celebration in 2010 and continues to play in Dublin. (Courtesy of Ron Geese.)

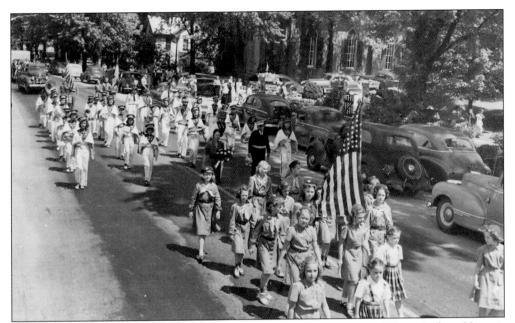

The Dublin High School marching band performs in the 1949 Memorial Day parade in Historic Dublin. Today's Memorial Day observances feature a bagpiper leading a procession from the Dublin Cemetery to the Grounds of Remembrance memorial, near the Dublin branch of the Columbus Metropolitan Library, for a service commemorating those lost during wars. (Courtesy of Dublin Historical Society.)

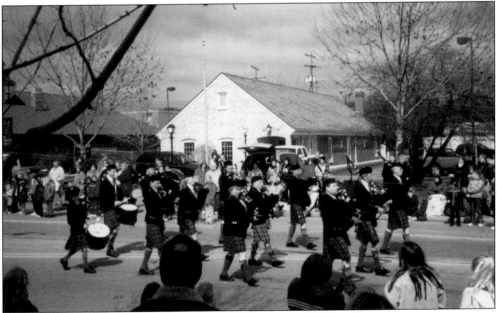

Members of Capital City Pipes and Drums march in the Dublin St. Patrick's Day parade in the 1970s. The bagpipe band has been a mainstay at all St. Patrick's Day parades and the opening ceremonies of the Dublin Irish Festival. Formed in 1963, the band has competed at Highland games in the United States and abroad, and along with the Capital City Highland Dancers, it celebrates Scottish music and heritage. (Courtesy of Columbus Metropolitan Library.)

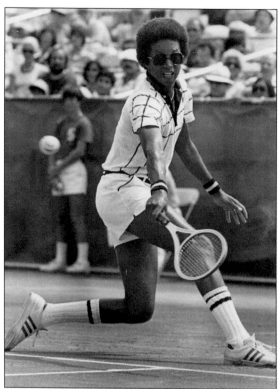

Famed tennis player Arthur Ashe displays his backhand in The Wendy's Tennis Classic at Muirfield Village Country Club on August 13, 1978. Also competing in the Grand Prix circuit major were Brian Gottfried, Guillermo Vilas, Raul Ramirez, and Tim Gullikson. Legendary broadcaster Bud Collins provided courtside commentary during the tournament. The event benefited Buckeye Boys Ranch in Grove City. (Courtesy of *Columbus Citizen-Journal*, Scripps-Howard Newspapers/Grandview Heights Public Library/Photohio.org.)

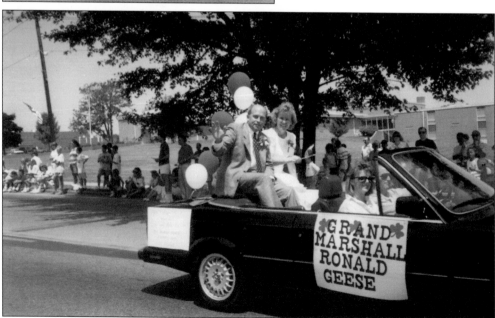

Ron Geese, the sixth generation of Charles Mitchell Sr. family descendants in Dublin, rides in the city's annual Independence Day parade with his wife, Anne. Ron was named "Outstanding Citizen" in 1990 and served as grand marshal of the parade. Ron was recognized for his many community contributions, including serving on Dublin City Council, the board of planning and zoning, and the board of zoning appeals. (Courtesy of Ron Geese.)

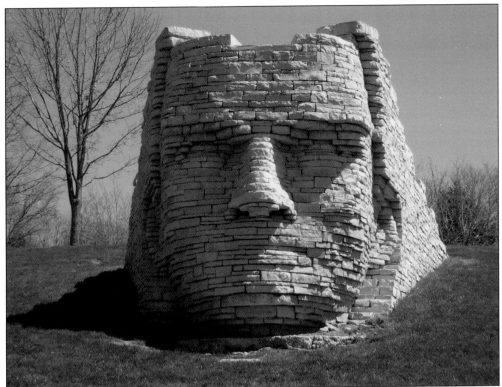

The first artwork commissioned for Dublin's Art in Public Places program, a partnership between the City of Dublin and Dublin Arts Council, paid tribute to Chief Leatherlips. Designed by Boston artist Ralph Helmick, the limestone sculpture in Scioto Park was dedicated July 1, 1990. (Courtesy of Columbus Metropolitan Library.)

Chief Leaford Bearskin, who was at the time the only living Wyandot chief in the United States, traveled to Dublin to bless the ground at the ground breaking of the Leatherlips sculpture in 1990. Bearskin passed away on November 9, 2012. Leatherlips is one of several installations in the City of Dublin and Dublin Arts Council's vibrant Art in Public Places program. Established in the late 1980s, the program, made possible through support from the city's bed tax fund, has received international acclaim. (Courtesy of Dublin Historical Society.)

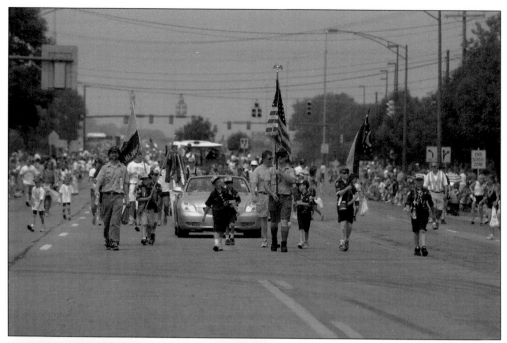

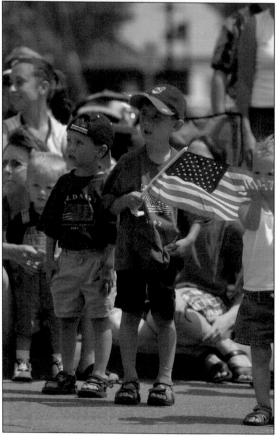

Boy Scouts remain a staple in Dublin's Independence Day parade. They are among more than 100 entries, which also include marching bands, floats, balloons, and other civic and community groups. Starting at Metro Center, the parade wends its way along Bridge Street and travels through Historic Dublin along High Street, much to the delight of spectators young and old. (Both courtesy of City of Dublin.)

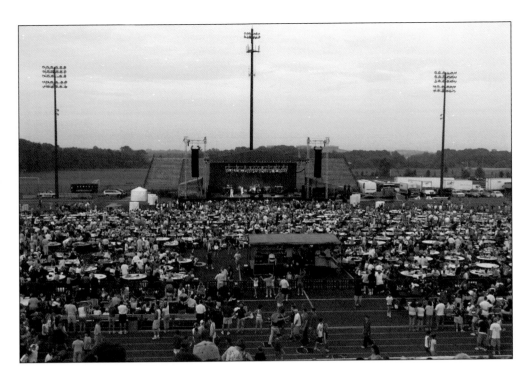

As part of Dublin's Independence Day celebration, live bands perform in the Dublin Coffman High School stadium before the fireworks are set off. Featured bands have included Chubby Checker; Huey Lewis and the News; Kool & the Gang; Chicago; and Earth, Wind and Fire. (Both courtesy of City of Dublin.)

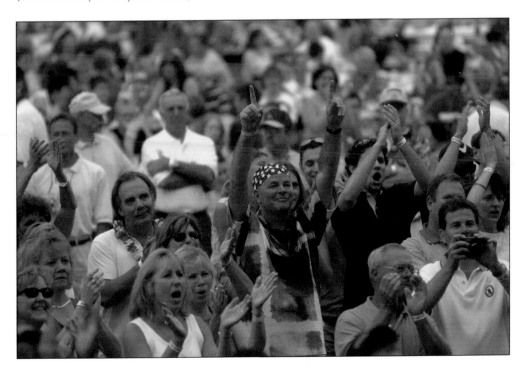

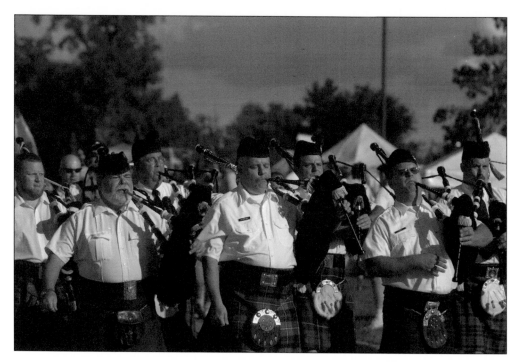

The Dublin Irish Festival, which began in 1988, has become the city's signature special event. Held annually during the first weekend in August, the festival attracts 100,000 people and features parades, live bands, dancing, and a celebration of Irish culture. Bagpipers, including the Columbus Police & Fire Pipes & Drums, help lead parades at the festival, where Irish dancers in costume are a common sight. (Both courtesy of City of Dublin.)

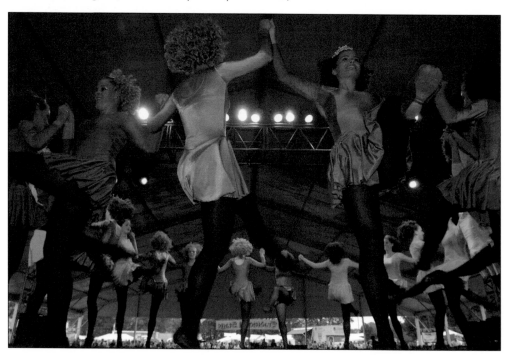

Ten

BOOMING BUSINESS

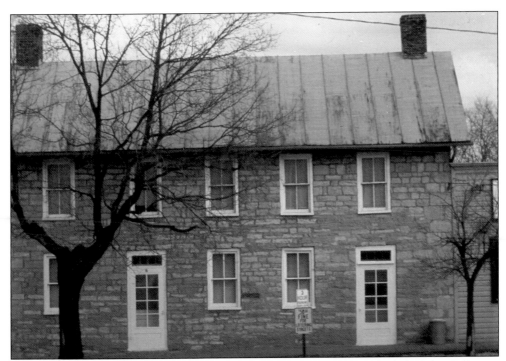

This venerable building still stands at 6 South High Street. Built in 1832 by John Sells as a wedding gift for his daughter Caroline and her husband, Zenas Hutchinson, over the years it has functioned as a hotel, the popular House of Christmas gift shop, and a Donato's pizza parlor. Zenas Hutchinson was not only an innkeeper but also the first mayor of Dublin. He died in 1893 at the age of 80. (Courtesy of Dublin Historical Society.)

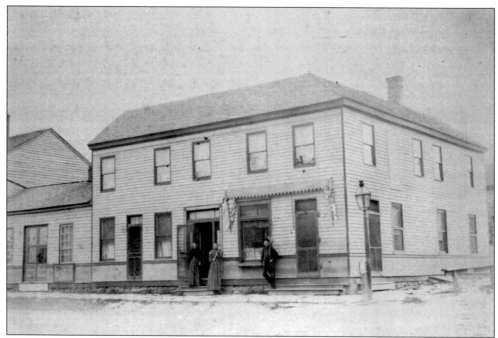

Henry Coffman built the Coffman Hotel in 1840 at the southwest corner of Bridge and High Streets, known as Coffman Corner. Henry's second great-granddaughter Madge Shriver operated Shriver's Lunch Room and Soda Fountain in the building from 1935 to 1950. Opening day on May 22, 1935, featured free ice cream and the Dublin Community Band. The building was demolished in 1961. (Both courtesy of Dublin Historical Society.)

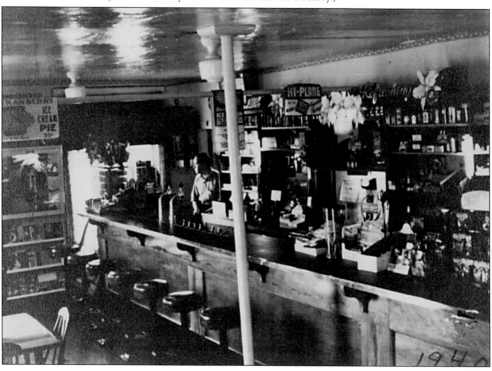

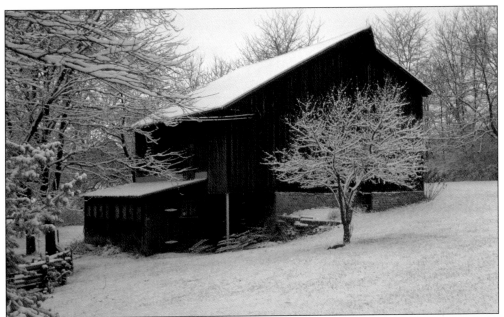

Blacksmith George M. Karrer came to Dublin from Germany in the 1850s. He purchased the James Wright farm in 1876 and built this bank barn on his property in the late 1870s. The barn, which was next to Karrer's blacksmith shop, remains at the same location at 225 South High Street to this day and is listed in the National Register of Historic Places. (Courtesy of Dublin Historical Society.)

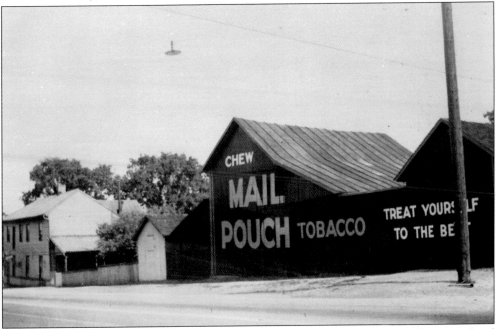

Coffman Corner included the ubiquitous Mail Pouch ad on a barn next to the Coffman Hotel and Shriver's Lunch Room. The ads were painted on barns from 1890 to 1992 by West Virginia–based Bloch Brothers Tobacco Company. Coffman Corner remained in the family until the buildings were torn down in 1961. (Courtesy of Dublin Historical Society.)

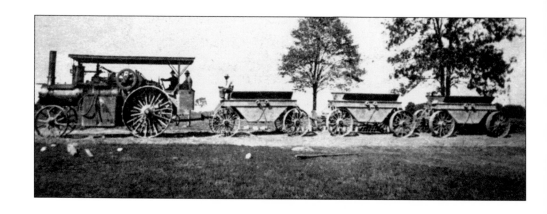

To build the roads in and around Dublin, stone was hauled from one of the J.L. Snouffer quarries. John L. Snouffer owned several quarries in Dublin beginning with one at Short and Riverview Streets, one on the east side of the river at Riverside Drive, shown below, and one off Dublin Road near where Donegal Cliffs Park is located today. Snouffer continued to operate the quarries until the 1950s. (Both courtesy of Dublin Historical Society.)

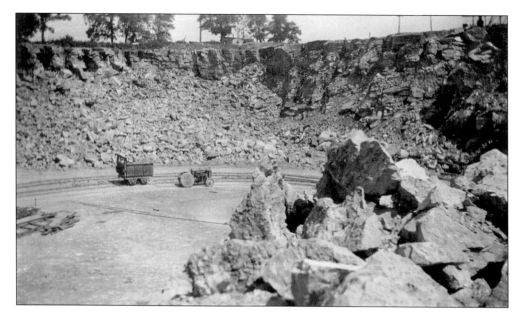

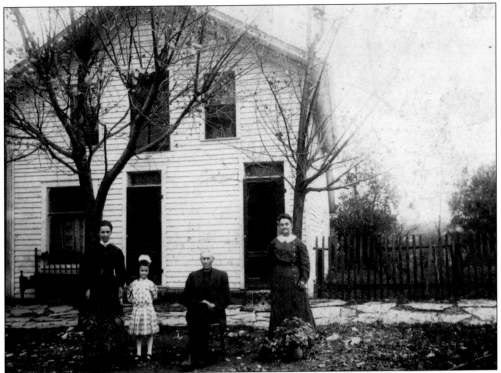

Vina (Mitchell) Bates was the proprietor of the Mitchell House, which served made-to-order dinners, at 24 South High Street. The photograph was taken about 1915. Vina was the wife of David Bates. The restaurant would later become Dr. Henry Karrer's office in the 1940s and is now the Dublin Barbershop. (Above, courtesy of Dublin Historical Society; right, courtesy of Laurie Termeer.)

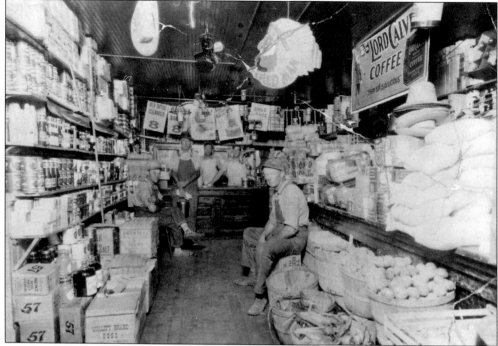

Leor Cole opened the Red & White Grocery Store on South High Street to supply residents with staples and fresh produce from local farmers. The business, shown as it looked in the 1920s, operated for more than 40 years with the Cole family residing in the building. Today, the building at 50 South High Street is home to Hair Smiths of Dublin. (Both courtesy of Dublin Historical Society.)

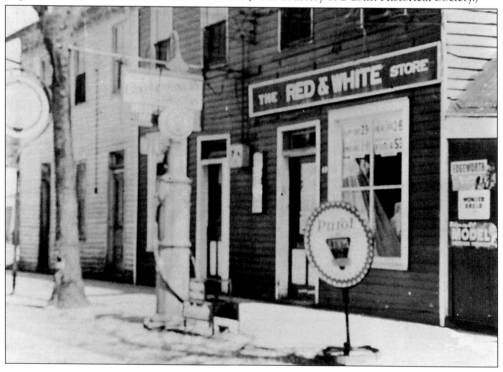

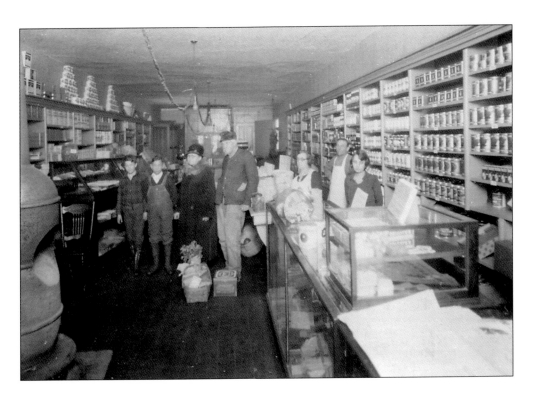

In 1929, Charles O. Geese opened his Dublin Grocery store in the building owned by Ele W. Tuller on South High Street in Historic Dublin. The Tuller family lived in the white cottage next to the commerce buildings, which were demolished in the 1960s. (Both courtesy of Dublin Historical Society.)

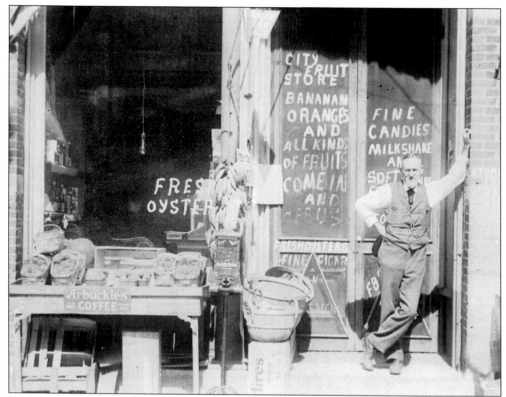

In the 1920s, Harry Price Grocery & Post Office took over the building previously occupied by Wing's Grocery & Harness Shop at the northeast corner of Bridge and High Streets. In this photograph from the late 1920s, Johnson Mooney stands in front of the shop. It would later become the Wertz Brothers Store before being torn down in 1935 to make way for the new bridge over the Scioto River. Prior to being razed, it also had a brief stint as Wings Pool Hall and Bar. (Both courtesy of Dublin Historical Society.)

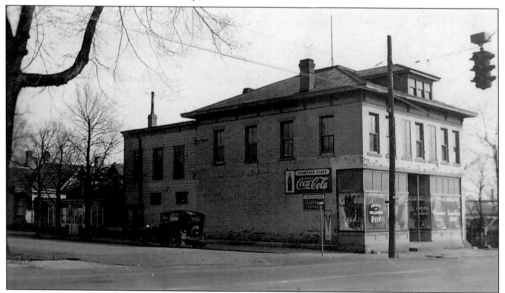

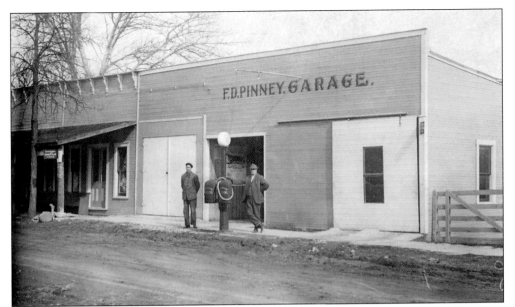

Frank Pinney and Jim Smith stand outside the F.D. Pinney Garage on South High Street in 1925. (Courtesy of *Columbus Citizen*, Scripps-Howard Newspapers/Grandview Heights Public Library/Photohio.org.)

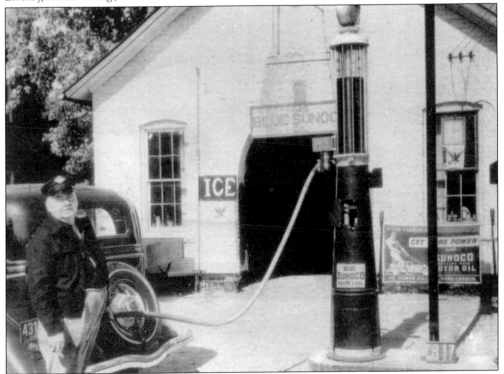

Blue Sunoco was introduced by the Sun Oil Co. in 1927 and marketed as "the High Powered Knockless Fuel at no Extra Price." Blue dye was added so that customers could tell the difference in the glass cylinder at the top of the gasoline pumps. Lyman Wright operated this station in the former T.J. Steinbower blacksmith shop. (Courtesy of Dublin Historical Society.)

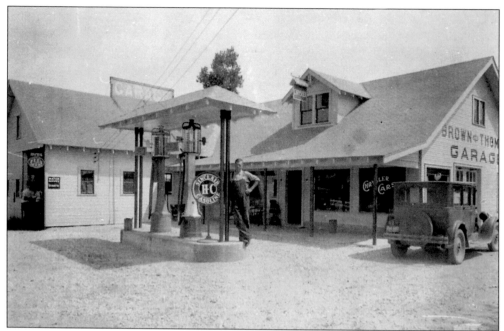

The Brown-Thomas Garage served travelers along Riverside Drive and Route 161 from the 1930s to the early 1970s. Basil Brown and John Thomas, who agreed to store the Dublin Fire Department's Reo Seagrave fire truck in the garage before a firehouse was built, owned the service station. (Courtesy of Dublin Historical Society.)

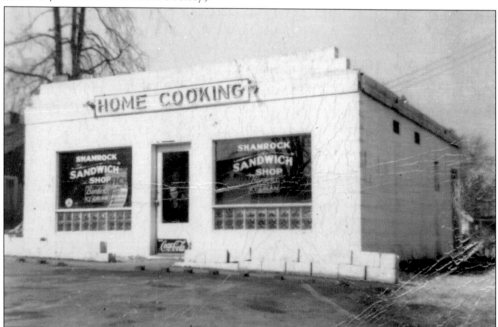

The Shamrock Sandwich Shop was a popular hangout. The restaurant, which opened in 1948, was especially convenient for nearby high school students who frequented it for lunch. The building, located at the corner of Bridge and High Streets, continues to draw Dubliners looking for a quick meal and is now home to Bridge Street Pizza. (Courtesy of Dublin Historical Society.)

John M. Herron owned the Dublin Food Market at 32 South High Street from 1954 to 1972. The building, erected in 1830, housed a variety of grocery stores over the years; Adam Hirth and Clark Coffman started Coffman's Market in 1932. Krouse's Market was the tenant in 1938 and was owned by Walter and Dora Krouse, who opened a post office in the shop in 1940. (Courtesy of *Columbus Citizen*, Scripps-Howard Newspapers/Grandview Heights Public Library/Photohio.org.)

The Online Computer Library Center, now known as OCLC, began in 1967, when a group of library leaders began using technology to reduce costs and improve service through a shared, online cataloging system. OCLC was first housed in a room of The Ohio State University's William Oxley Thompson Memorial Library before moving to 1125 Kinnear Road. (Courtesy of OCLC.)

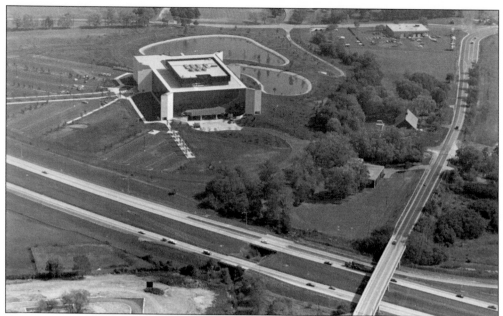

Mid-Ohio Volkswagen, which was Dublin's first major corporation in the 1960s, built its headquarters at Frantz and Post Roads and was visible from the newly built Interstate 270. Known as "Midvo," the building was designed by architect Perkins + Will to wrap around a man-made lake offering a view of the water feature from inside the concrete, glass, and steel structure. (Courtesy of *Columbus Citizen-Journal*, Scripps-Howard Newspapers/Grandview Heights Public Library/Photohio.org.)

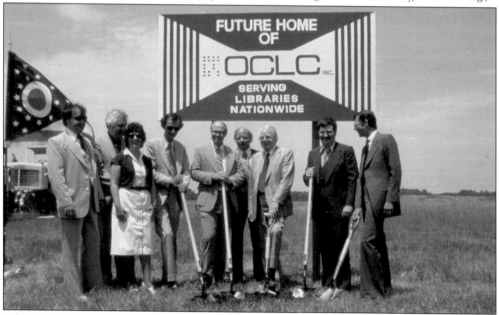

When Midvo's headquarters moved to be closer to railroad and trucking needs, the Online Computer Library Center, which was located in an adjacent building, decided to expand its headquarters onto the former car company's property. OCLC broke ground for its new headquarters in Dublin on June 5, 1979. Pictured third from right is founder, president, and executive director Frederick G. Kilgour, and on the far right is board of trustees chairman H. Paul Schrank Jr. (Courtesy of OCLC.)

OCLC founder, president, and executive director Frederick G. Kilgour is shown in his office in 1984. Kilgour stepped down as chief executive officer in 1980. He passed away on July 31, 2006, at the age of 92. Later that year, the City of Dublin renamed the street leading to OCLC Kilgour Place in his honor. (Courtesy of OCLC.)

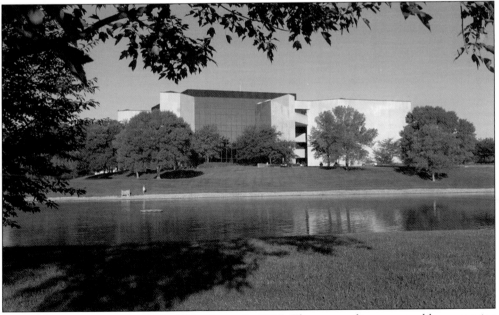

The Dublin headquarters of OCLC is shown in 2007. The nonprofit computer library service and research organization now counts 25,900 libraries, archives, and museums in 170 countries as members. OCLC's services, which include WorldCat—the world's largest online library database—allow researchers to search among two billion items from more than 10,000 libraries worldwide. (Courtesy of OCLC.)

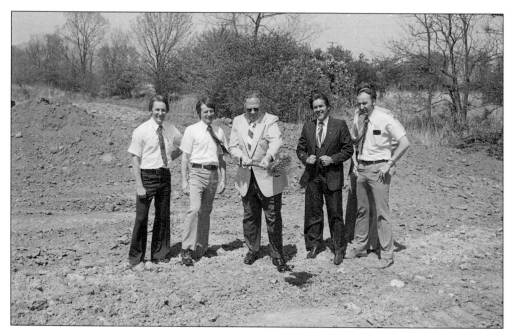

The Wendy's Company founder Dave Thomas breaks ground for the company's new Dublin headquarters, which opened in 1976. Pictured at the ground breaking ceremony are, from left to right, John Houck, Chuck Finlay, Thomas, Bob Barney, Hank Sherowski, and Tom Santor (behind Sherowski). (Courtesy of The Wendy's Company.)

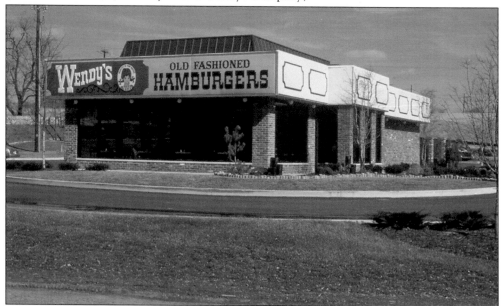

The Dublin Wendy's restaurant was located at the corner of West Dublin-Granville Road and Riverside Drive in March 1979. The restaurant was demolished in 2013 to make way for a new state-of-the-art Wendy's just east of this site. The new restaurant includes memorabilia from the company's history, including beads, a newsprint table, Tiffany-style lamp, and chairs from the first Wendy's restaurant, as well as a bronze statue of late founder Dave Thomas. (Courtesy of The Wendy's Company.)

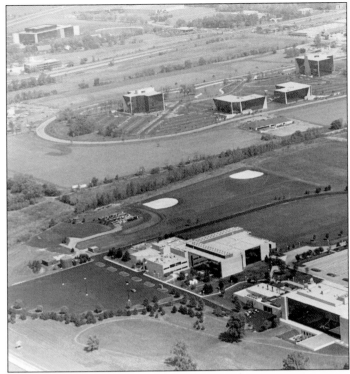

Three events are credited with creating the exponential growth Dublin experienced between the 1970s and 1990s: the construction of Interstate 270, the development of Muirfield Village, and the arrival of Ashland Chemical Company, now known as Ashland Inc. In this aerial view of Dublin from October 2, 1983, Ashland's new buildings can be seen at the bottom center. The new Metro Center office park is at the top center, and far left at the top is the Mid-Ohio Volkswagen headquarters. (Courtesy of *Columbus Citizen-Journal*, Scripps-Howard Newspapers/Grandview Heights Public Library/Photohio.org.)

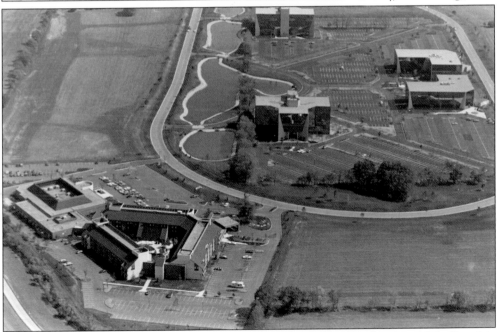

This aerial shot from October 2, 1983, shows the new Stouffers Hotel at lower left. Based in Cleveland, Stouffers became Dublin's first major chain hotel when it opened at Metro Center. Now part of the Crowne Plaza chain, the hotel is one of 15 in Dublin, which boasts more hotels than any other Columbus suburb. (Courtesy of *Columbus Citizen-Journal*, Scripps-Howard Newspapers/Grandview Heights Public Library/Photohio.org.)

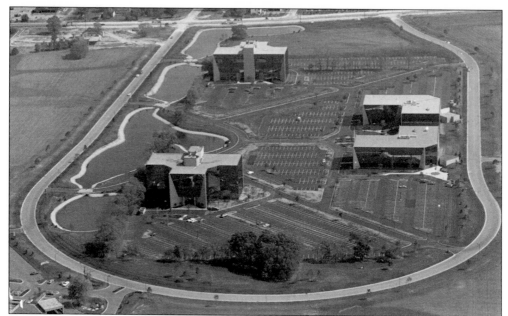

This aerial shot showcases Dublin's new Metro Center on October 2, 1983. Located off Frantz Road and with highway frontage along Interstate 270, the modern office park was ahead of the pack when built in the early 1980s. By the year 2000, the 130-acre park, developed by the Pickett Companies, included 13 office buildings totaling more than 1 million square feet of office space. (Courtesy of *Columbus Citizen-Journal*, Scripps-Howard Newspapers/Grandview Heights Public Library/Photohio.org.)

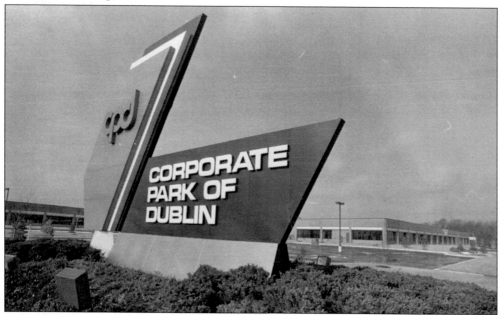

The sign at Shamrock Court and Shier Rings Road announces Dublin Corporate Park in 1984. The industrial area fronts Interstate 270 and is now home to the headquarters of one of Dublin's marquee businesses, Stanley Steemer International. (Courtesy of *Columbus Citizen-Journal*, Scripps-Howard Newspapers/Grandview Heights Public Library/Photohio.org.)

In 1971, Dublin native and recent Harvard University graduate Robert D. Walter purchased Monarch Foods, renaming it Cardinal Foods. Within 10 years, Cardinal Foods was a prominent regional food distributor. In 1979, Walter redirected the company into pharmaceutical distribution. Renamed Cardinal Health, it is now Ohio's largest publicly held company and regularly ranks in the Fortune 20. Its distinctive headquarters, which expanded in 2009, rises above Interstate 270 on Emerald Parkway. (Courtesy of Cardinal Health.)

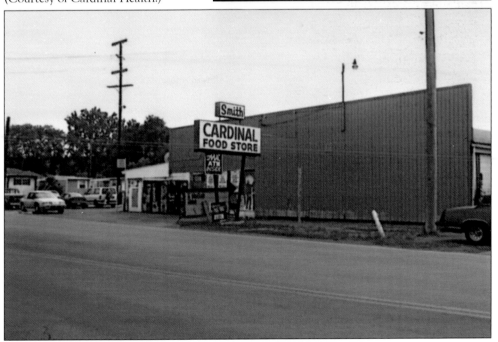

DISCOVER THOUSANDS OF LOCAL HISTORY BOOKS FEATURING MILLIONS OF VINTAGE IMAGES

Arcadia Publishing, the leading local history publisher in the United States, is committed to making history accessible and meaningful through publishing books that celebrate and preserve the heritage of America's people and places.

Find more books like this at
www.arcadiapublishing.com

Search for your hometown history, your old stomping grounds, and even your favorite sports team.